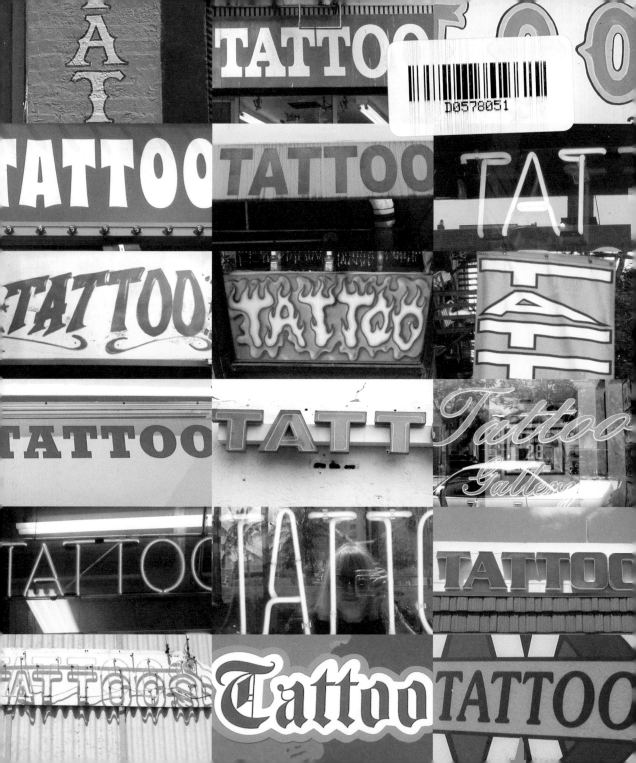

BODY TYPE 2

MORE TYPOGRAPHIC TATTOOS

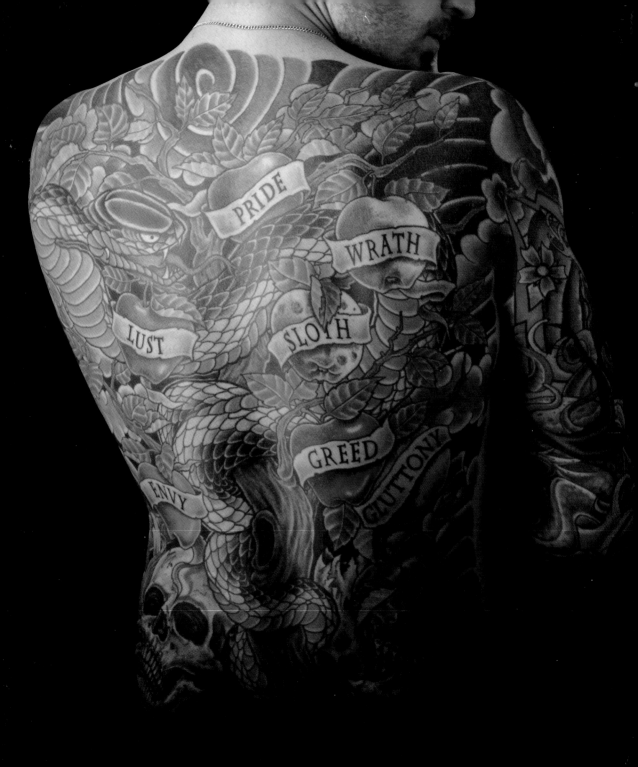

BODY TYPE 2

MORE TYPOGRAPHIC TATTOOS

INA SALTZ

Abrams Image
New York

Editor: Tamar Brazis
Designer: Ina Saltz
Production Manager: Jacquie Poirier

Library of Congress Cataloging-in-Publication Data
Saltz, Ina.
 Body type 2 : more typographic tattoos / by Ina Saltz.
 p. cm.
 ISBN 978-0-8109-8276-5 (hardcover with jacket)
 1. Tattooing. 2. Words in art. I. Title.
 GT2345.S253 2010
 391.6'5—dc22

 2009035085

Copyright © 2010 Ina Saltz
Cover photographs © 2010 Ina Saltz
Number spiral courtesy of screaMachine.
"Push PSDs" courtesy of Glenn Sorrentino.
"La Serenissima" courtesy of Michael Stinson.
Rimbaud quote courtesy of Rubistyle.
"Danielle" courtesy of Stephanie Tamez.
"Born to Letter" courtesy of Ed Rachles.
"Optimist" courtesy of Gene Pittman.
Please see page 190 for interior illustration credits.

Printed and bound in China
10 9 8 7 6 5 4 3 2 1

Abrams books are available at special discounts when purchased in quantity for premiums and promotions as well as fundraising or educational use. Special editions can also be created to specification. For details, contact specialmarkets@abramsbooks.com or the address below.

115 West 18th Street
New York, NY 10011
www.abramsbooks.com

Dedicated to my husband, Steven

CONTENTS

INTRODUCTION

Why **Body Type***?*

After publishing *Body Type: Intimate Messages Etched in Flesh*, I received many letters from fans, photos of tattoos, and inquiries about how I came to document the phenomenon of typographic tattoos. As I began to collect images for a new volume, I found myself answering the same three questions from my fans and subjects.

How did you get the idea for **Body Type***?*

My involvement with the world of tattoos began in the most unlikely of ways. In the summer of 2003, I was traveling crosstown in New York City on the M86 bus when I spotted an interesting-looking young man with a large, text-only tattoo on his right forearm; it spelled out "happy" in a typeface which I instantly recognized as Helvetica. The fact that it was in lowercase letters and so tightly kerned that the letters were touching was especially intriguing to me as a designer and a typophile. I had never seen a tattoo quite like this one—sans serif! Not being in the habit of talking to strangers in New York City, I debated mightily before approaching him . . . but my curiosity finally got the better of me. "Are you a graphic designer?" I asked. Why, yes, he was. "And would you mind if I took a photo of your tattoo to show my students? I teach typography at City College." No problem. I whipped out my digital camera and managed to get one shot and to grab his proffered business card before I jumped off at my stop. That evening I uploaded the photo and went to the Web site on his business card to send him the image with a proper thank-you message. Imagine my astonishment to find our entire conversation recounted on his blog!

Always searching for interesting topics for articles that I write on design-related topics, I seized upon the notion of documenting this new style of tattoo: unadorned words rather than images. Fortuitously, not far away, a huge tattoo convention was happening that very weekend. I called my editor, who arranged for a press pass. An article soon followed, and, when I realized that no one had ever specifically documented typographic tattoos in book form, the idea for a book called *Body Type* was born.

Where did you find these typographically tattooed people?

As often happens when encountering something new, having seen one typographic tattoo, I then started to see them everywhere (it was August and a lot of skin was visible). It seemed almost as if I had developed a third eye that had the unique ability to spot typographic tattoos, in conjunction with an uncanny instinct about who, in a crowded room, was most likely to be "sporting ink." I learned to keep my camera and model releases with me at all times. Wherever I went—to a party or the beach or to a gallery opening or other professional event—I always discovered a typographic tattoo or someone who knew someone who had one. Many of my favorite tattoos from both books resulted from these serendipitous encounters, rather than from seeking people out online or at tattoo conventions. Especially after the publication of the first volume of *Body Type*, many people with typographic tattoos simply found their way to me.

Miked in the Fox News "green room" with New York–based tattoo artist Stephanie Tamez.

Do you have any tattoos?
No. Although I like to joke that I do and that they are in a place too intimate to expose, for many reasons I do not have a tattoo and am unlikely to ever get one. I do have a great respect for the very permanent choice to commit to a tattoo but, as a designer, I find I inevitably want to redesign, and so I cannot make such an irrevocable commitment. I also have a phobic fear of needles, so I do not even have pierced ears (or any other pierced body parts). Thus it is a great irony that I am documenting an art form which requires repeated penetration of one's skin with needles!

***That you are reading* Body Type 2** testifies to the unstoppable trend of typographic, or, as I like to call them, "intellectual" tattoos. The first volume of *Body Type* was published by Abrams Image in September 2006. Perhaps because this was the first time special attention had been paid to the subject of tattoos composed specifically of words, passages of text, and letterforms, or perhaps because the subject had been presented in a scholarly and design-focused format,

Body Type received a good deal of media attention and popular acclaim, especially within the creative community.

Much has happened in the few years since the release of *Body Type*. I could not have predicted that the book would go into several printings to satisfy the demand for it here in the United States and abroad, even in non-English-speaking countries where distribution was sparse or nonexistent. I received (and continue to receive) e-mail messages from all corners of the globe (Brazil, Switzerland, South Africa, Holland, Australia, Italy, Paraguay, Denmark, England, France, and, of course, throughout the United States) from fans. A graphic design student in Tasmania based her college thesis on *Body Type*, which was itself published in a handsome volume. People sent me photos of their typographic tattoos; in fact, many of those pictured in this new volume said their tattoos were directly inspired by *Body Type*.

Among my favorite e-mails were touching thank-you messages from people whose tattoos had appeared in *Body*

Interview for *Access Hollywood* at the Inkslingers Ball in L.A.

***Body Type* on display at a bookseller's stall in Florence, Italy.**

At the New York Public Library, where *Body Type* was honored.

9

Type, saying that, because of the context of my book, and the presentation of their tattoos, their families finally "understood" and appreciated the motivation and commitment represented by their tattoos.

Body Type became a cult hit, liberally touted on tattoo, design, and typography blogs, and honored by a number of important literary acknowledgments, bringing my work to the attention of an entirely unexpected (and very wide) audience. To my delight, *Body Type* sold everywhere from the Metropolitan Museum of Art to Urban Outfitters, and it appealed to a broad spectrum of readers: from young to old and from those who were simply curious about people with tattoos to those who were heavily tattooed.

Several shows of my photography from *Body Type* followed the book's publication, and these shows garnered their own media attention. I did book signings at several tattoo conventions, where I was even asked to judge on-site tattoo competitions. I gave presentations about *Body Type* to professional groups, including the Type Directors Club, the Art Directors Club, the Society of Scribes, the Registered Graphic Designers of Ontario, the Art Directors Invitational Master Class, and at the Baltimore Tattoo Museum. I appeared on *Access Hollywood*, CBS News, and Fox News, and discussed typographic tattoos on radio talk shows. In my wildest imaginings, I never expected this project to be

so warmly embraced and celebrated, nor that I would meet such fascinating individuals as I conducted my research. *Body Type* has really changed my life, and its effects continue to unfold in wonderfully unpredictable ways.

I was a very early and avid reader. I remember being fascinated by letterforms as far back as second grade, where I often daydreamed while gazing above my teacher's head at the lowercase and uppercase letters of the alphabet displayed atop the blackboard: *Aa, Bb, Cc,* etc. I loved making up stories about each of these letters, which seemed to have distinct personalities and lives. For example, the capital *B* was a buxom lady carrying a bag of groceries. The capital letter *I* was a soldier, standing at attention. At age ten or eleven, I acquired a broad-edged dip pen and some ink, and I noticed that it created shapes that had thick and thin strokes, if I held the broad edge of the pen at different angles. I didn't know until my first year of art school, at age sixteen, that the broad-edged pen was the classic tool used to create handwritten letterforms, before the advent of moveable type in the fifteenth century. Luckily for me, calligraphy (from the Greek, *kalli graphos,* or "beautiful writing") was a required course at Cooper Union, where I was finally properly instructed in the techniques of letter-making . . . it was an art form that I hadn't known existed, and it quickly became my favorite form of artistic expression. I love letterforms as an artist because they are

At the Snug Harbor Cultural Center opening reception for a show of photography from *Body Type*.

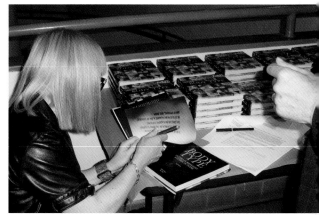

A book signing and opening reception for an exhibition of *Body Type* at Cooper Union's Lubalin Center.

beautiful images in their own right. I love letterforms as a reader because they form words and sentences, they convey meaning, and they are the instruments which "embody thought". . . what could be better? Our letters have a grand and glorious history — without them, how could civilization progress? My calligraphy teacher only allowed us to write "important" texts, as our calligraphic efforts were worthy of nothing less. He taught us that by studying the interconnected shapes of the letterforms we could learn universal principles of art, principles that applied to every artistic field: balance, harmony, rhythm.

So it is not surprising that I gravitated toward a career which allowed me to express my talents using letterforms (or typography) as a major creative tool: editorial design. For over twenty years, I worked in some pretty intellectually heady environments as a "visual journalist," that is, as a magazine design director, whose job it was to amplify and clarify the meaning of the written word for the reader, using type and image. And in my second career, as a professor of design, I have the pleasure of transmitting my passion for typography and knowledge about letterforms to a new generation of designers.

I believe that we are now firmly ensconced in a new "golden age" of typography. Some of the best type designers are only at the dawn of their careers. Young designers are excited by the vast panoply of typographic forms (about 90,000 by some rough estimates). The ease of acquiring digital typefaces, and the ability to create their own typefaces, have encouraged experimentation and eclectic choices. This has inevitably been reflected in the typographic tattoos abounding in the youthful population.

A word about the stories behind the tattoos in the first book of Body Type.

Because of my professional typographic background, my intention was to identify a connection between the message of the tattoo (the substance) and the subject's typographic choice for the expression of that message (the style). I sought to understand why specific typefaces had been chosen, and, as a designer, to comment on the appropriateness of the choice and the success of its execution. However, my investigation necessitated delving into the reasons behind the

message, which inevitably led (sometimes deeply) into the complex and intense lives of my subjects. I decided that the stories behind the tattoos needed to be told, even if briefly, in order to understand why people chose to put themselves through the pain and suffering that even the simplest tattoos require. Even though I tried to keep the photographs' captions concise and directed, they turned out to be a major factor in *Body Type*'s popularity. People (no real surprise here) are interested in other people: what moves them, what inspires them, what impels them. *Body Type* provided a unique glimpse into the psyches of the tattooed and readers were fascinated. So, in *Body Type 2*, wherever possible, I have included more details about the stories behind the tattoos.

Some of my observations since the publication of Body Type.

Although the trend toward typographic tattoos has only continued to increase (with more and more celebrities, sports stars, musicians, actors, and models leading the way), one strong subtrend is group "bonding" tattoos, with more than one person getting the same tattoo, or being a part of a larger tattoo. Besides boyfriend-and-girlfriend tattoos, husband-and-wife tattoos, sibling tattoos, and parent-child tattoos, groups of friends are getting tattoos together.

Tattoos are now so prevalent, especially in the eighteen to twenty-nine age group, that they have become acceptable in almost all levels of society and they are rarely a bar to advancement. Any prejudice still associated with tattoos will inevitably wane as the tattooed generations grow up and assume leadership of our society and institutions. For now, it is my wish that readers will embrace what I have learned during the course of researching and documenting both volumes of *Body Type*. I hope that their sensibilities will be transformed, that their stereotypical notions about tattoos will be dispelled, that they will come to appreciate and respect the motivations behind tattoos, and that they will gain greater insight into the human condition.

I hope that by bringing more of these stories and body art to light, readers might consider their own beliefs and power to transform their bodies, souls, and perhaps even the world around them. Most of all, I hope to continue to document the intriguing trend of body type for many years to come.

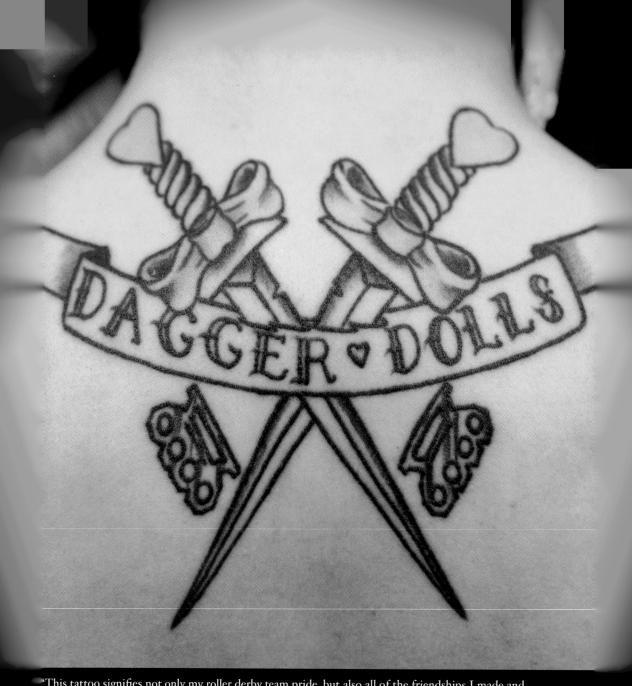

"This tattoo signifies not only my roller derby team pride, but also all of the friendships I made and

ONE:
LOVE & TRIBUTE

PAYING TRIBUTE to a child, parent, or lover; memorializing the dead or remembering a past relationship; swearing allegiance to a cause or simply swearing a love of love itself. These tattoos represent passion made visible: passion through pain, a vivid declaration of the wearer's devotion.

Homage may also take other forms: the truest gesture of a fan to a favorite sports team, artist, or enterprise. These heartfelt marks signal a deep commitment. What better way to bear witness to one's feelings for another human being or entity than to inscribe it on one's most precious possession: one's self.

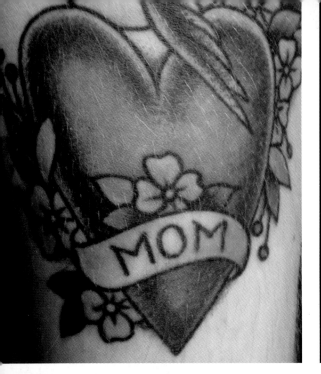
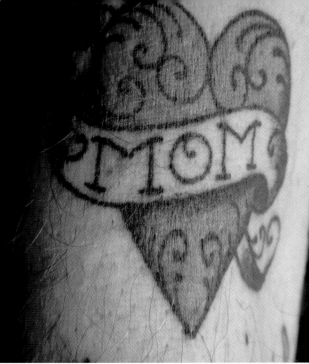
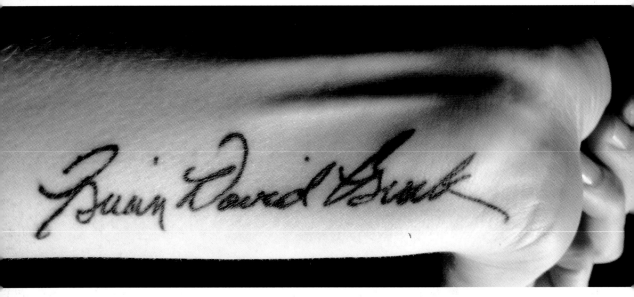

Top and right: tributes to mom. *Above:* "My dad passed away three years ago. This is his signature. My idea was that this was like an artist signing his artwork. I wanted to pay tribute to him even though we had a tumultuous relationship. I know he loved me. I am his one and only child, and he was my one and only father."

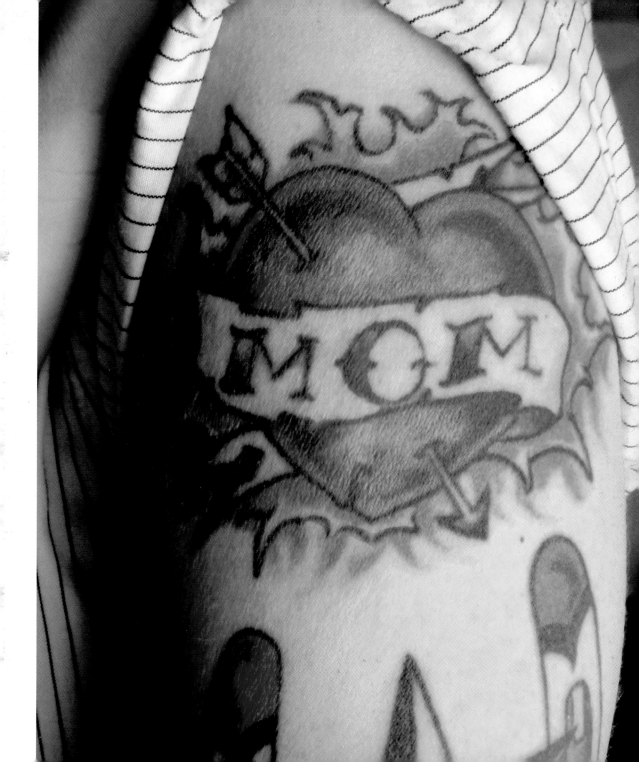

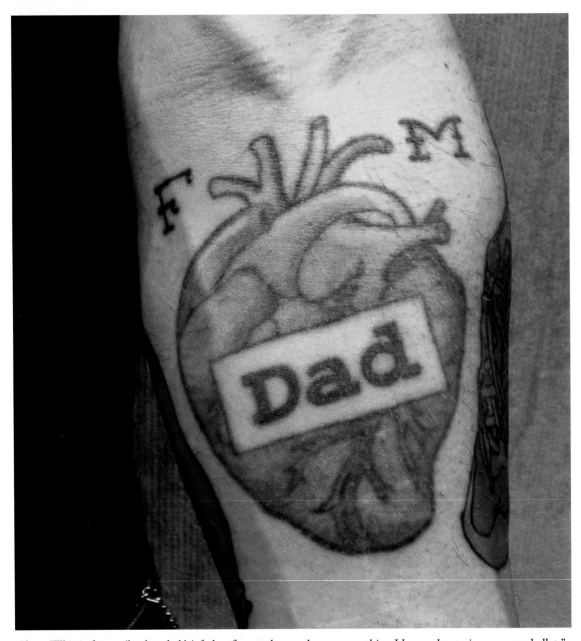

Above: "This is for my 'leather dad.' A father figure who taught me everything I know about cigars, opera, ballet."

Right: "My dad was so touched that he cried when he saw I got this tattoo to honor him. The dagger has a handle-bar mustache, just like the one he has always had."

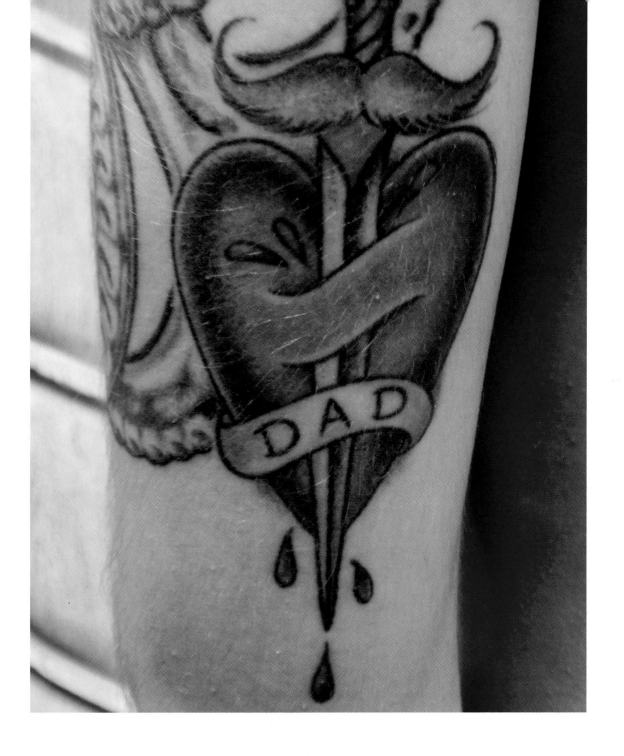

Above: "These numbers are really special to me because they are my dad's airplane number. He died when I was fourteen, piloting his plane, alongside a friend. I wanted to remember his plane number forever because flying was his greatest happiness and that plane was his fourth baby (after his three baby girls, of course)."

Right: "These initials are a way to honor my lineage: my grandfather's initials, my father's initials, my initials. I had hoped it would hurt more than it did. I wanted to understand a fraction of the pain my father had been going through with his chemo before he died."

"I had been in a relationship for five years when my girlfriend got a Fulbright to study in Paris. There was a dramatic year of chaos. Her name was Zoé (with the accent over the *e*). I got the tattoo maybe for her birthday, but in hindsight I realized it was the end. Another reason for the *e* is that I read her a Salinger short story called 'For Esmé with Love and Squalor.' My girlfriends have been total font geeks."

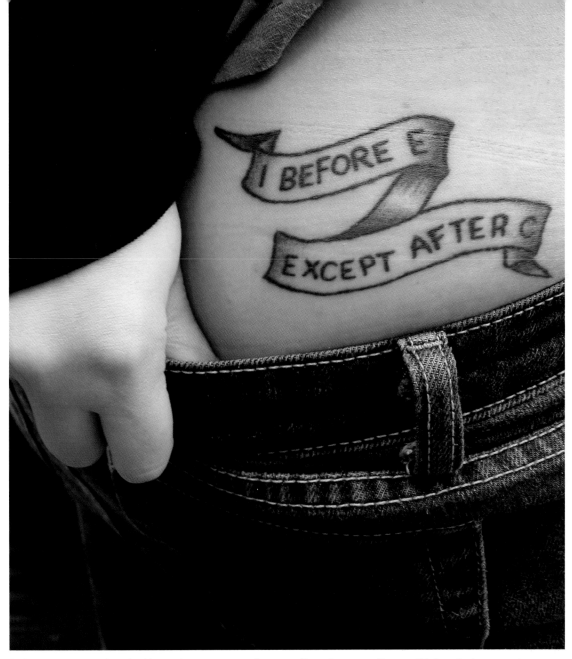

"This tattoo is an idea I had been throwing around since college. I am an editor and I thought it was a witty, tongue-in-cheek way to pay homage to my profession. I wanted the text in a traditional banner, like 'mom' or 'dad' because that made it both more ironic and classic."

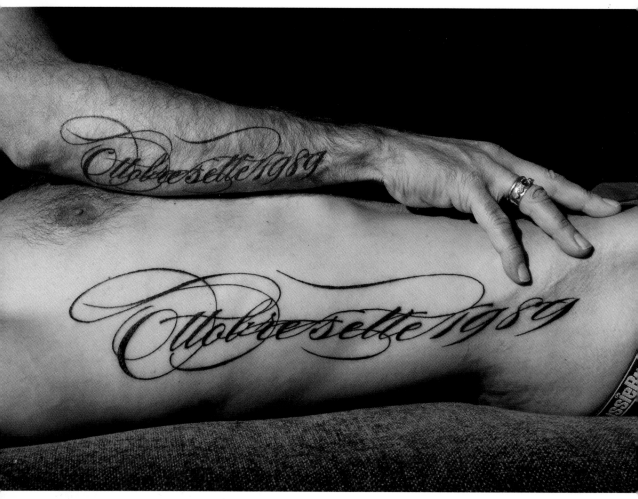

"The tattoos commemorate our anniversary in Italian, October seventh, 1989. We got these as declarations of love in a time when gay men are still not able to wed legally, at least not in Arizona. It's coming up on twenty years for us, and if that isn't a commitment, I don't know what is."

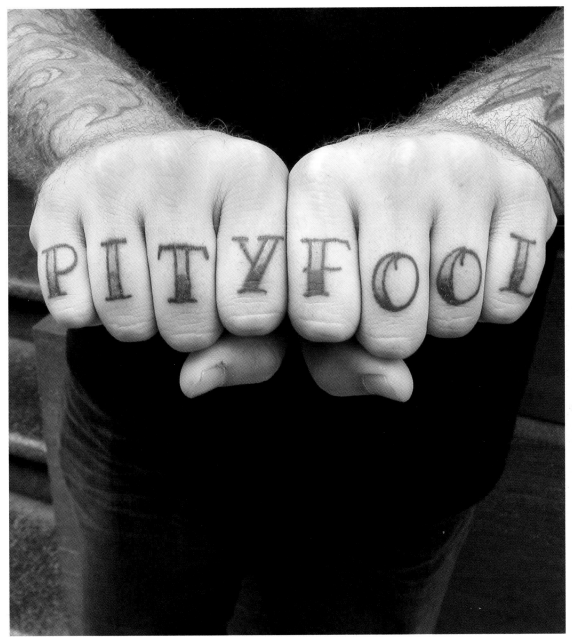

"I have had a lifelong obsession with Mr. T. And there is also a secondary meaning, a kind of pun: piti-ful."

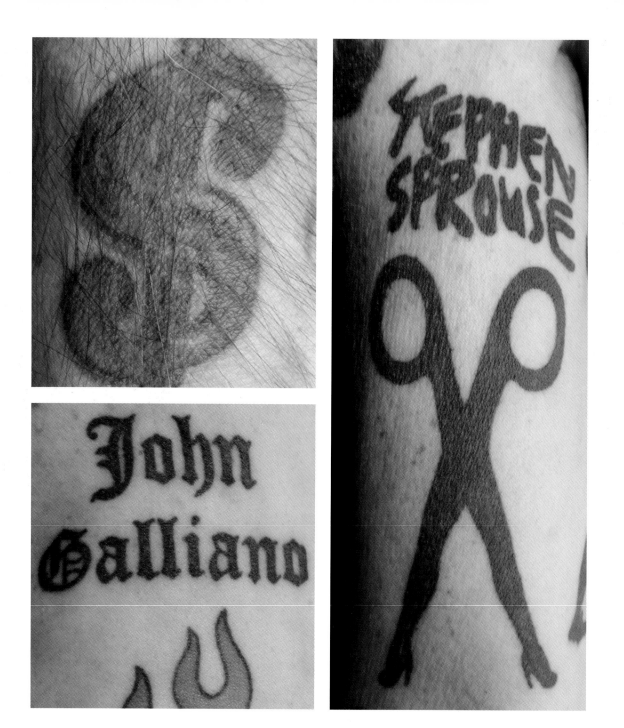

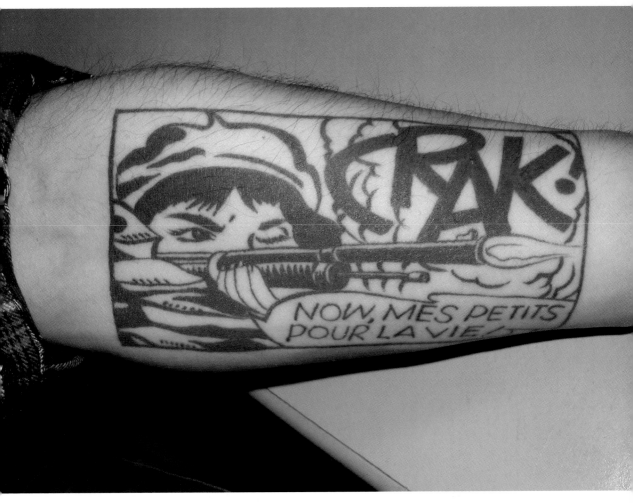

Typographic homage to Andy Warhol, designers Stephen Sprouse and John Galliano, and Roy Lichtenstein.

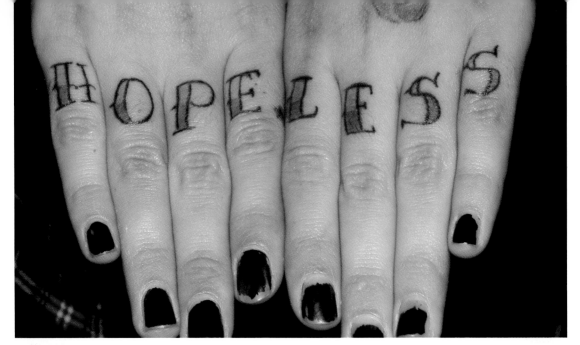

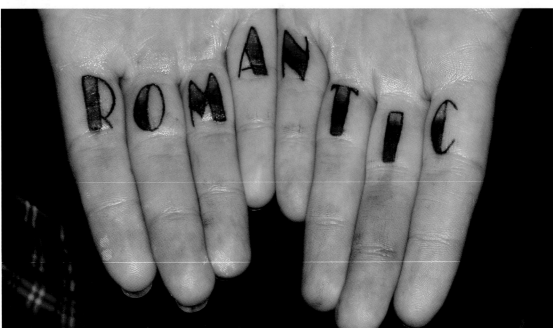

"'Hopeless Romantic' pretty much speaks for itself."

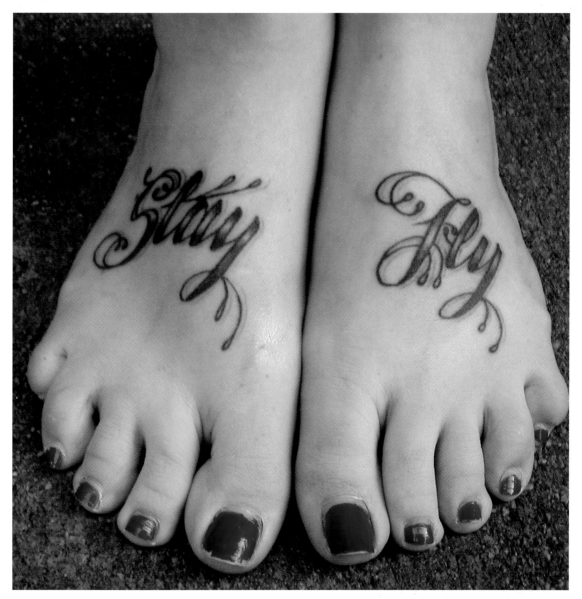

"My friend Justin was a tattoo artist. 'Stay Fly' is a Three Six Mafia song we would all dance to. One night he ripped open his shirt and showed me a 'stay fly' tattoo on his chest to cheer me up. Soon after that he was killed in a car accident, so a bunch of his friends got the exact same tattoo, from his tattoo artist friend Scotty, who did all the tattoos for free as a tribute to Justin."

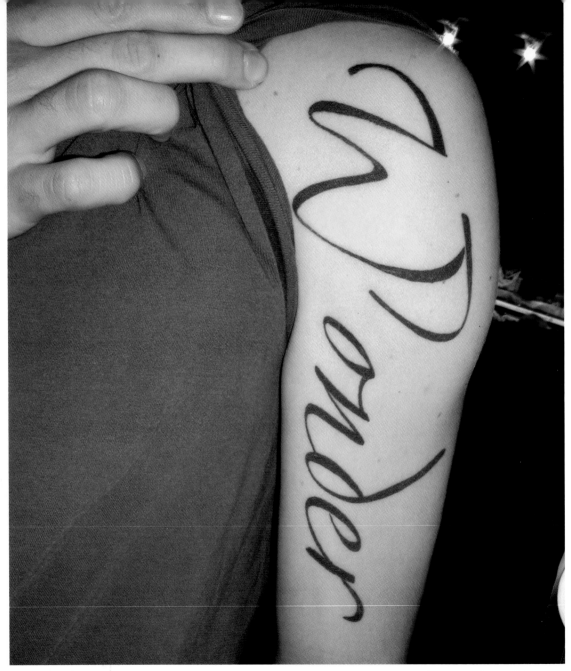

"My tattoo is about the wonderment of love. I chose this typeface because I like the decorative shape of the *W*. The placement was especially important, because when you lie in bed with someone, you want her to rest her head in that spot, and then you almost wrap her up in it."

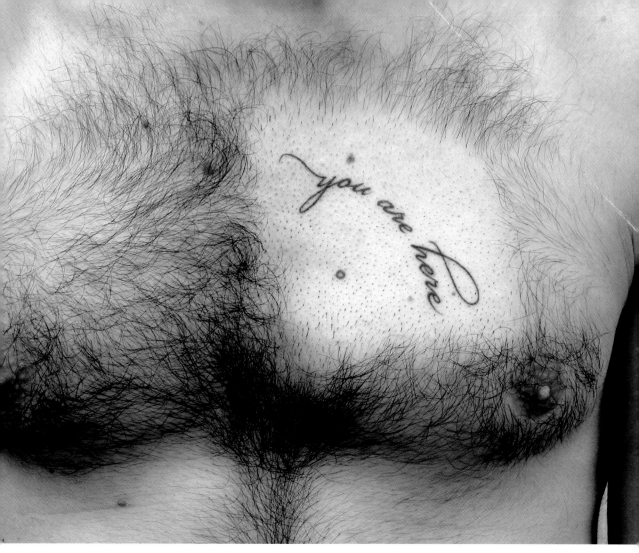

"This is about how to touch someone you love. My partner, who is Belgian, had an immigration problem. I was looking for a secure place for our couplehood, so I wanted to etch this into my skin, in a physical place unthreatened by immigration. I made certain it was anatomically over my heart, and I chose Bickham Script because I wanted it to be beautiful. And I wanted the flourish to show if I had a button-down shirt open."

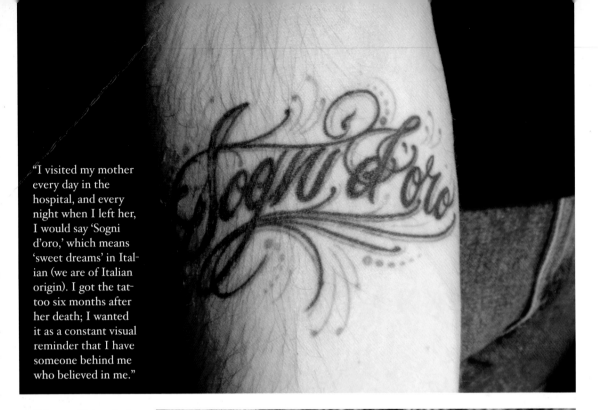

"I visited my mother every day in the hospital, and every night when I left her, I would say 'Sogni d'oro,' which means 'sweet dreams' in Italian (we are of Italian origin). I got the tattoo six months after her death; I wanted it as a constant visual reminder that I have someone behind me who believed in me."

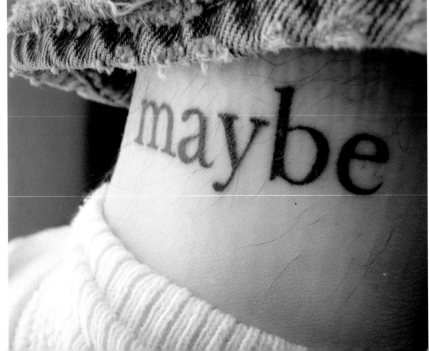

"My grandfather died in 1985. I was 16. I had once told him that he only loved me because we were related. He responded by saying that if he hadn't known me he would go out and find me so he could love me. The moment before I found out he died, I was writing out the chorus to the Bruce Springsteen song 'Atlantic City': 'Everything dies baby that's a fact, but maybe everything that dies someday comes back.' So this tattoo has been my own private prayer. Until now."

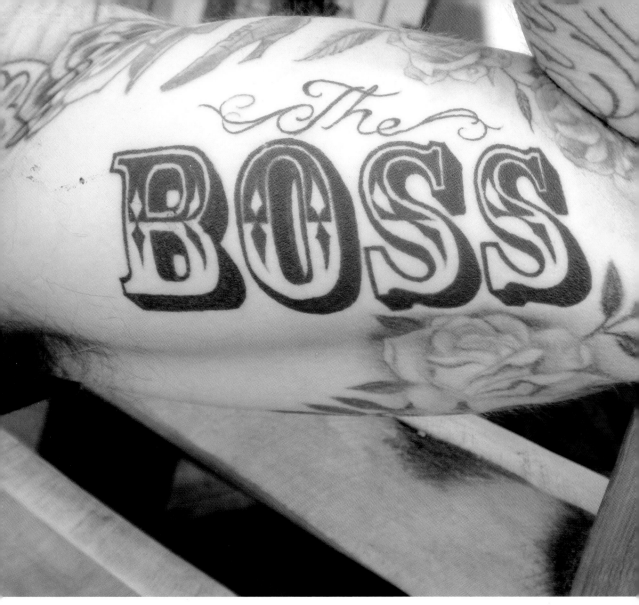

"My boyfriend and I have matching tattoos. Everyone thinks it is because we are bossy and stubborn, but actually it is from the Diana Ross song that says love is 'the boss.' It means that the power of love is just that. You always try to be in charge of your own heart, but it doesn't work that way. So, love is the boss."

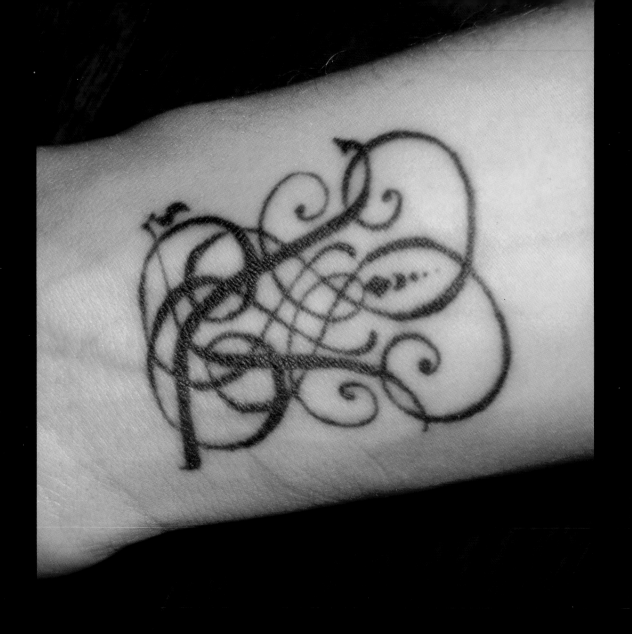

"The letter *A* is an important part of my family heritage. I am the youngest of three girls, and my parents named us all with *A*s after my great grandfather, and also after my dad's brother, who passed away at a young age."

TWO:
ME, MYSELF & I

WHETHER YOU CHOOSE to view self-love as a narcissistic obsession or a healthy expression of self-esteem, the tattoo marking the wearer's own identity is perhaps the most popular form of typographic tattoo. This act of demarcation sets the wearer apart and is a dramatic means of proclaiming one's individuality and originality.

The uniqueness of one's identity may be signified by a name or a nickname, by a birth date or astrological sign, by a defining personal characteristic, or by a logotype of one's initials. The tattoo is often a form of self-actualization—the motive for realizing one's full potential— also expressed as the desire to become closer to one's intrinsic self.

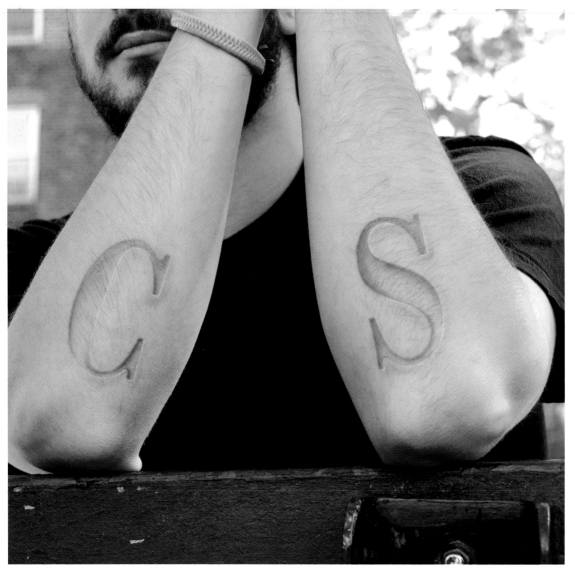

"These are my initials, tattooed in a gray wash, no black, with white highlights. It's Bodoni Condensed, which I tweaked a little, rounding the part where the serif meets the letter."

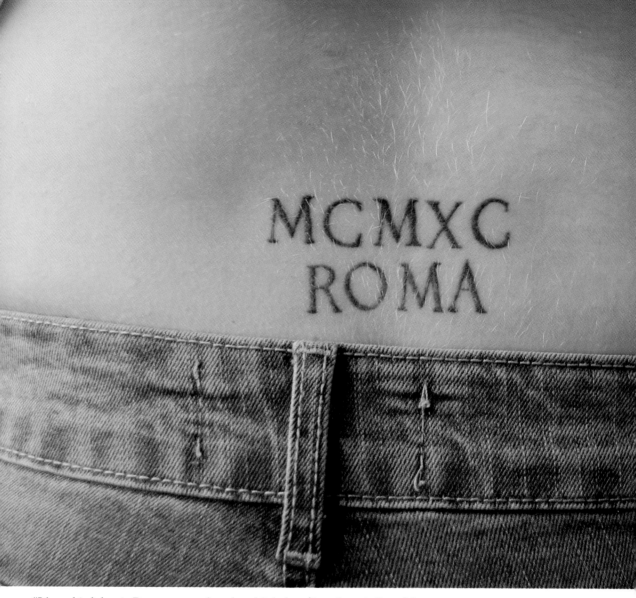

"It's my birthdate in Roman numerals and my birthplace (I was born in Rome)."

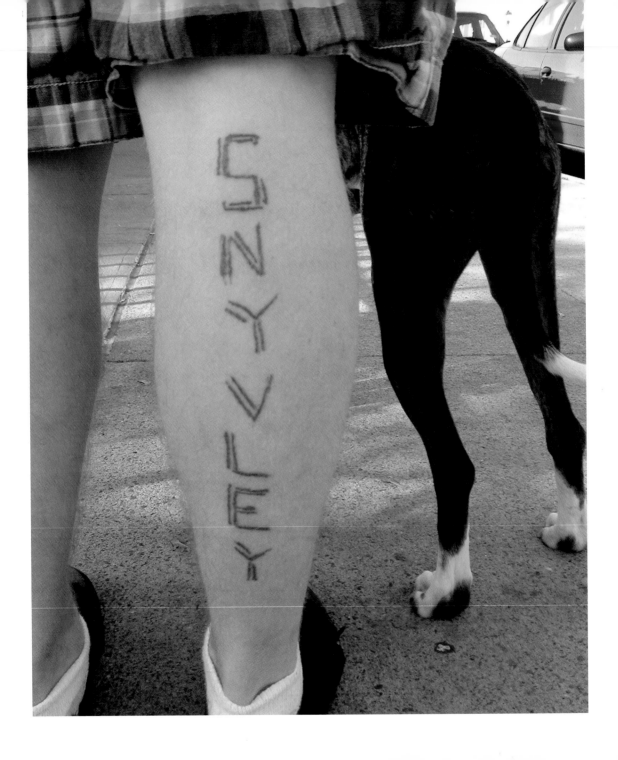

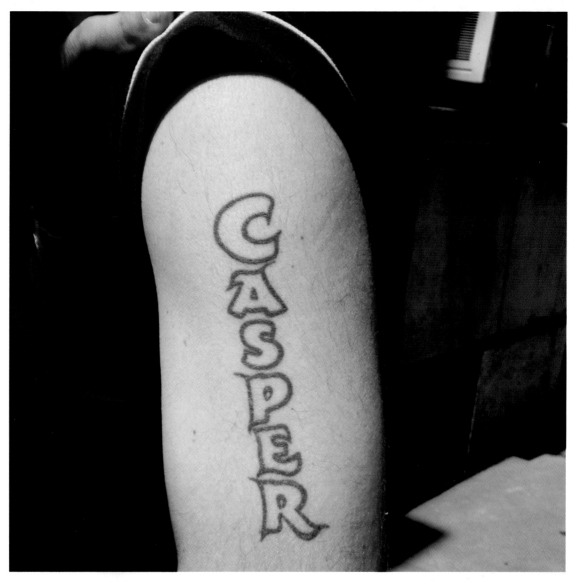

Left: "My girlfriend did this tattoo; she had never tattooed before. Two days afterward, we broke up. This is my nickname since I was young, given to me by my mom, the most precious person in my life. It's like Snidely Whiplash, from *The Rocky and Bullwinkle Show*, but we misspelled it."

Above: "I started DJ-ing when I was 14; this is my DJ name. The artist designed the letterforms to resemble the well-known *Casper the Friendly Ghost* logo. It is based on my own ghost-like fantasy: I would be here, there, and everywhere, doing good deeds wherever I went, so that people would look forward to my return."

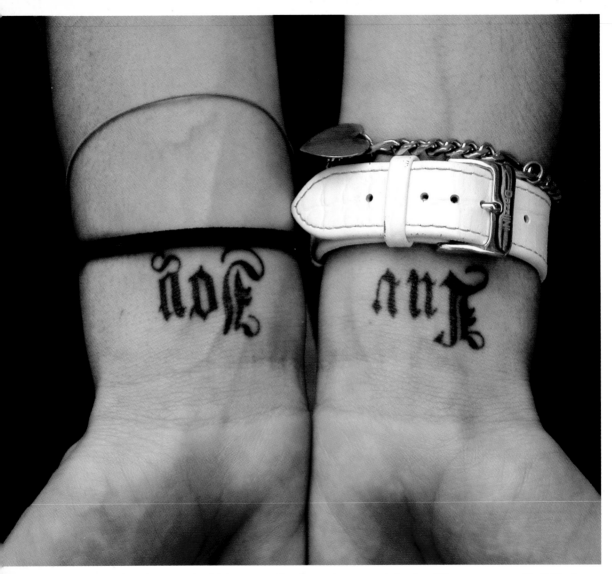

"I met my best friend in pre-school. Her name is Luv Joy, and my name is Joy Luv. We were separated by life's circumstances at age twelve, but happily we found one another again at age twenty-one, and we got opposite tattoos."

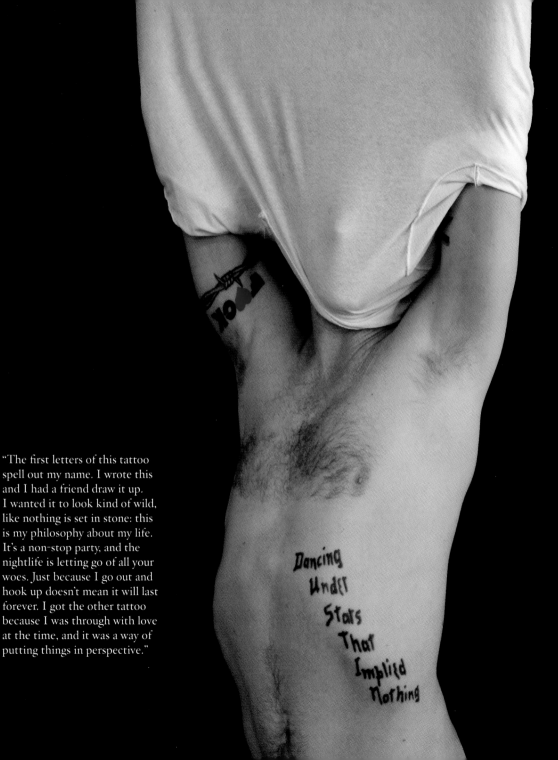

"The first letters of this tattoo spell out my name. I wrote this and I had a friend draw it up. I wanted it to look kind of wild, like nothing is set in stone: this is my philosophy about my life. It's a non-stop party, and the nightlife is letting go of all your woes. Just because I go out and hook up doesn't mean it will last forever. I got the other tattoo because I was through with love at the time, and it was a way of putting things in perspective."

Dancing
Under
Stars
That
Implied
Nothing

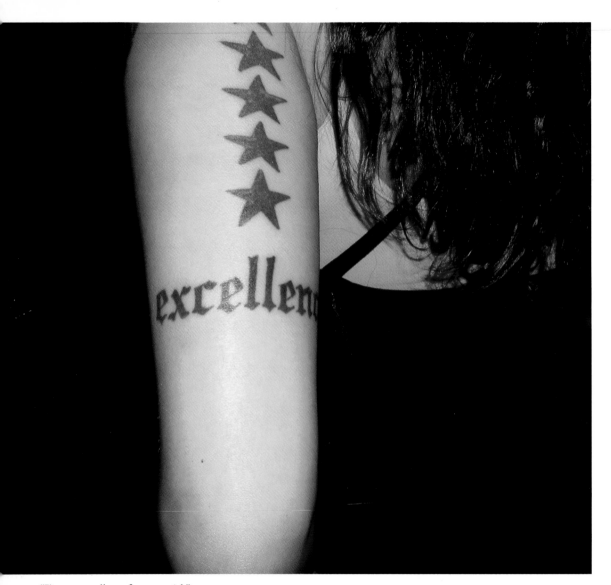

"I'm an excellent, five-star girl."

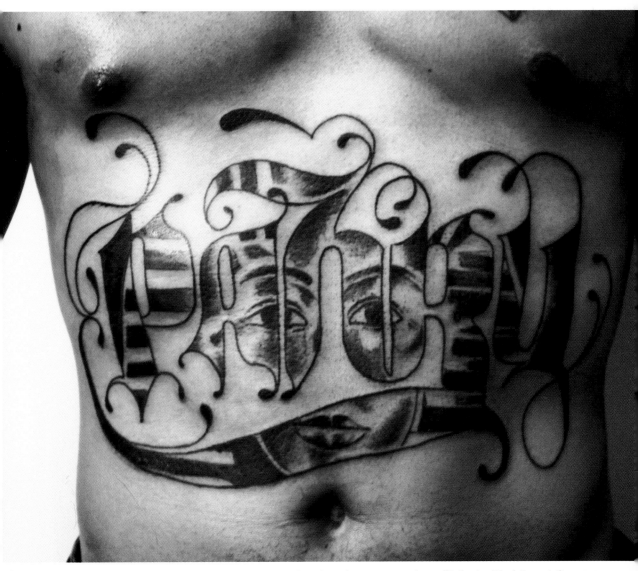

"My father is an Egyptian priest and I was raised to identify with Egyptian culture. ('Pahru' is like 'pharoah.')
The tattoo represents my Egyptian roots."

Names, initials, and nicknames for oneself are some of the most prevalent forms of the typographic tattoo. Here, a sampling of letterforms chosen by the wearer to represent his or her identity.

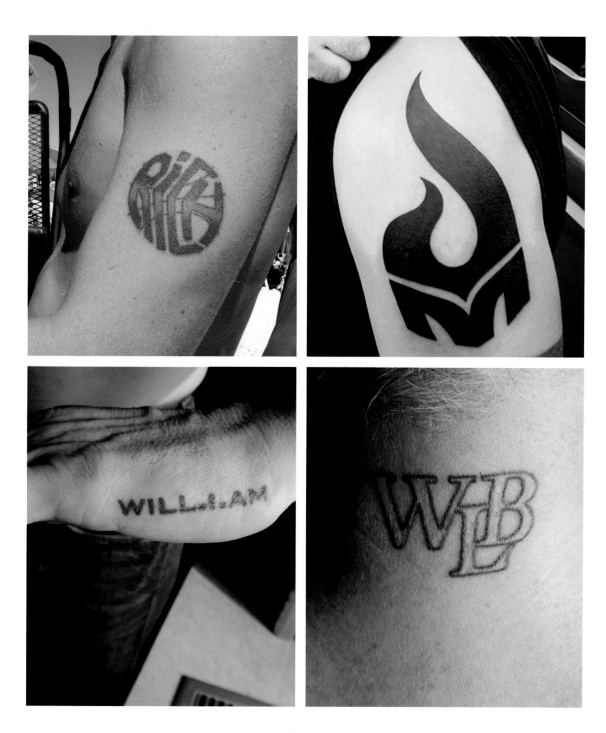

"This is my statement about how we are all interconnected. It's hand-drawn."

"A nickname that my friends gave me. The name of the typeface is Santa's Big Secret."

"This is the first word I learned how to spell as a little boy. I wanted a really bold but simple typeface, like what you would see in a children's book. I am a sculptor at a casino sign company in Las Vegas. A lot of my work involves three-dimensional typography."

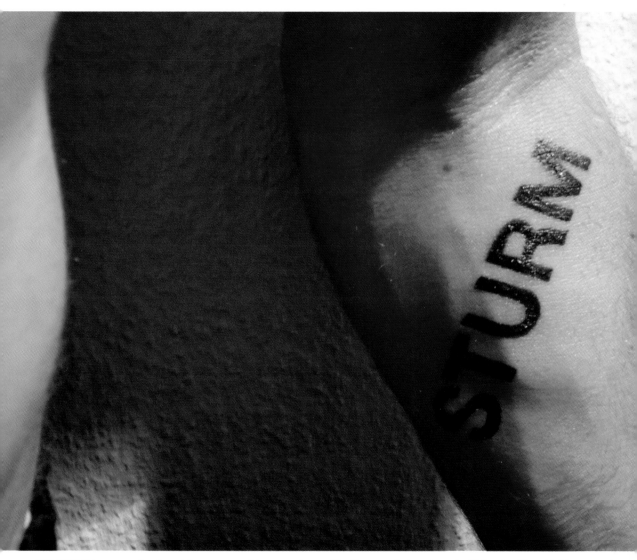

"'STURM' is my mother's maiden name and it means 'storm' in German. It is written in Helvetica Neue Bold. I am from Switzerland (Helvetia) and the point size is 77 point. 1977 is my birth year.

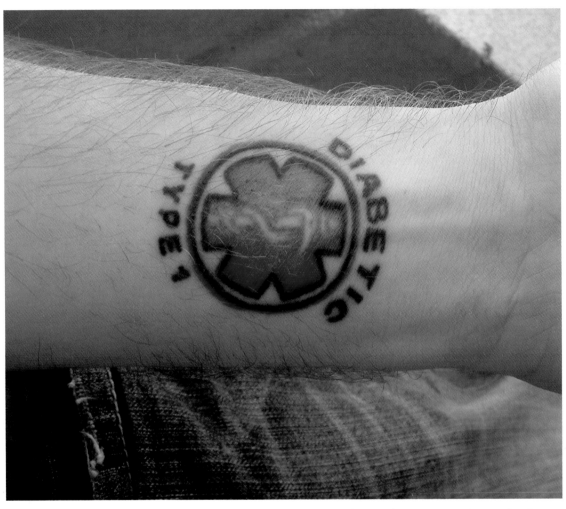

"I do graphics and web design and I play a lot of hockey. I designed this tattoo (which is my only tattoo) to be visible in case I am injured while involved in a sport where I may not have ID on me. The type is Helvetica Neue Inserrat Extended Bold."

"We are identical twins. These are our initials, done by ourselves when we were seventeen, using a sewing needle wrapped with thread and India ink we stole from our high school photography class. These are our only tattoos."

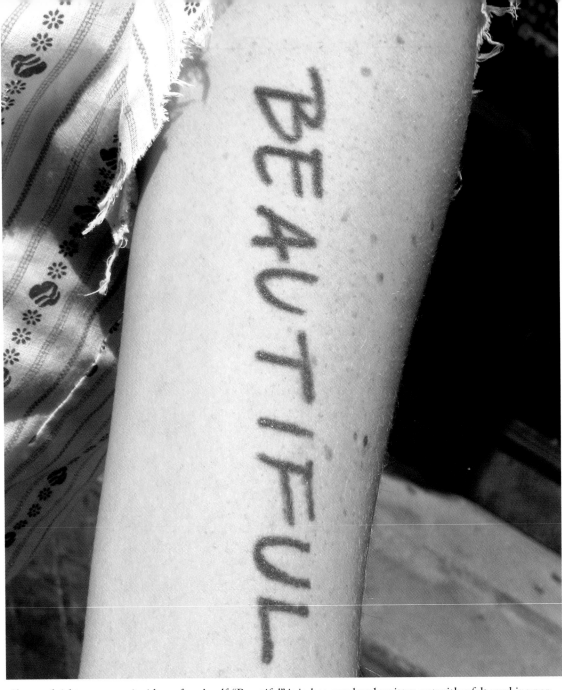

Above and right: two opposite ideas of one's self. "Beautiful" is in her own hand, written out with a felt marking pen for the tattoo artist. "Freak" is a fraktur typeface and "Void" is based on a heavy Optima-like outlined typeface.

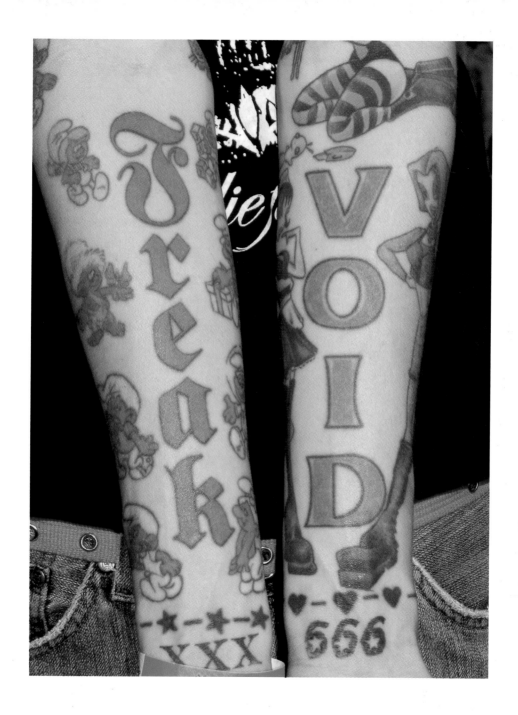

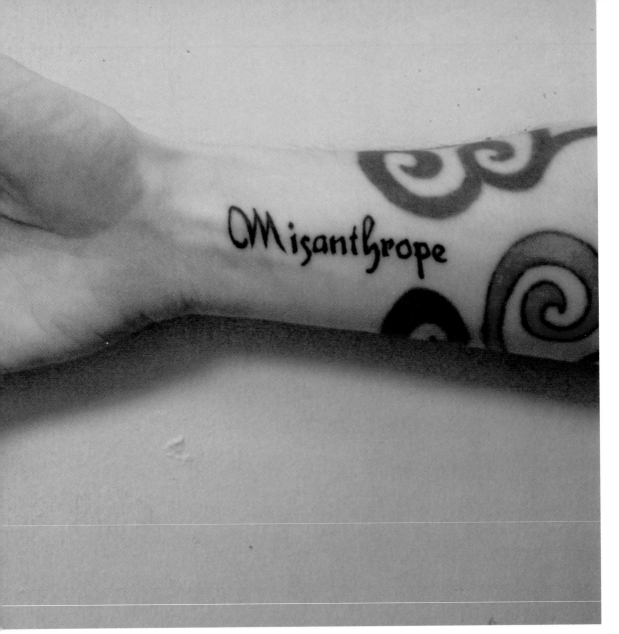

"I didn't think of having a type tattoo until I saw *Body Type*. It's my first and only word (I am heavily tattooed). The definition of a misanthrope is someone who hates and distrusts mankind. I am a loner by nature; this is who I am and it is not going to change with age. I wanted it in a place where people could see it but I want to read it, too."

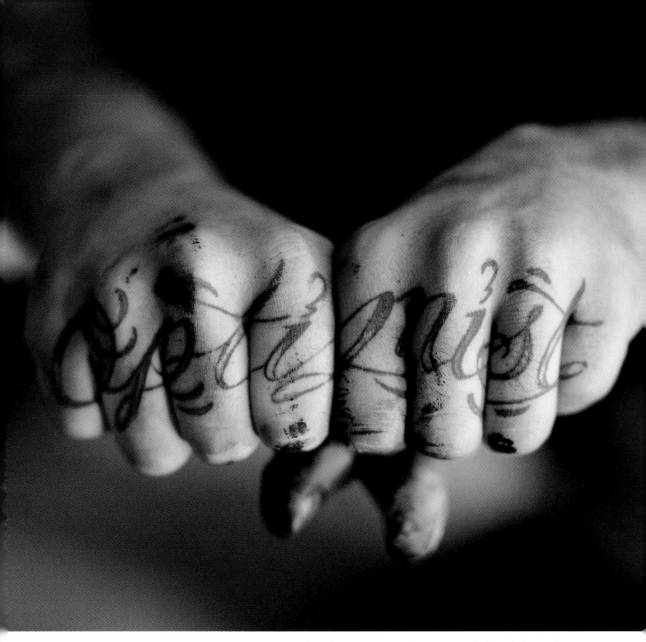

"I wanted to get tough knuckle tattoos; nothing is tougher than an optimist, because you feel good about whatever happens, no matter what it is. I am a painter; I share living space with a good friend who got this same tattoo."

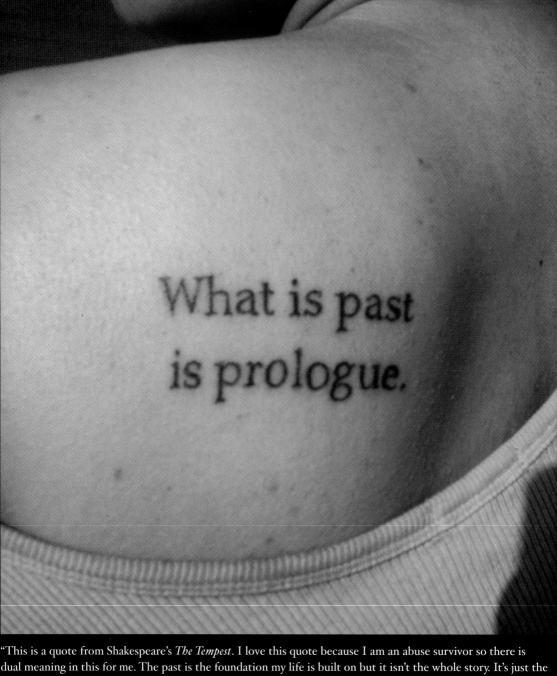

"This is a quote from Shakespeare's *The Tempest*. I love this quote because I am an abuse survivor so there is dual meaning in this for me. The past is the foundation my life is built on but it isn't the whole story. It's just the beginning, but it is at the core of me all at once. I designed this tattoo and chose Palatino as the typeface; I wanted a book font because I love books and words."

THREE:
POETRY & LITERATURE

THESE TATTOOS represent the core values of typographic tattoos: the love of words and ideas that could not be expressed in any other form but through the text itself, excerpted from the original passages of authors and poets. These inscribed texts testify to the power of words in all their glory. Words affect us, they influence us, they move us.

Choosing to commit a meaningful text to one's flesh is an homage to the importance of these very specific words in our lives. Rimbaud and Hunter Thompson, Shakespeare and Robert Frost, e. e. cummings and Anne Sexton are some of the writers and poets who inspired these indelible literary tributes.

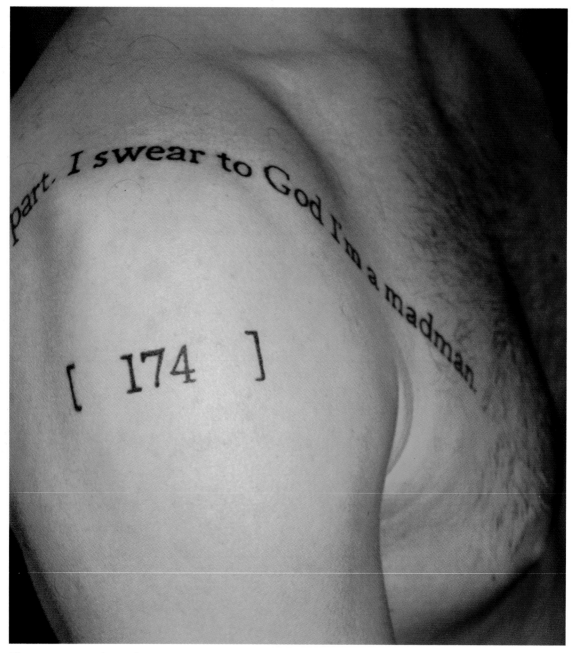

This is a page number and a quote by Holden Caulfield from chapter 17 in J. D. Salinger's *Catcher in the Rye*. "That's the terrible part. I swear to God I'm a madman."

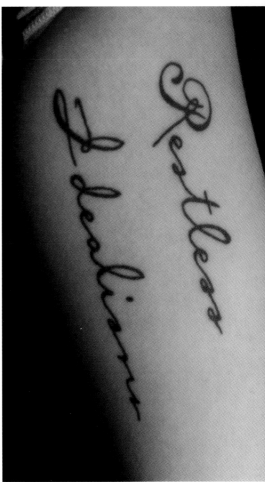

"These are recovery tattoos. I got them the day I decided to get sober. They are from one of Hunter Thompson's early novels called *The Rum Diaries*. A character named Kemp who is probably based on Thompson says 'I shared a dark suspicion . . . that the life we were leading was a lost cause, we were all actors, kidding ourselves along on a senseless odyssey. It was the tension between these two poles—a restless idealism on one hand and a sense of impending doom on the other—that kept me going.' That magnetic energy is what keeps me in a straight line, without leaning too much to either sentiment. I was inspired by the Texas Hero tattoo in *Body Type*; I loved the script on the arm. I chose the typeface Carpenter because it reminded me of that tattoo."

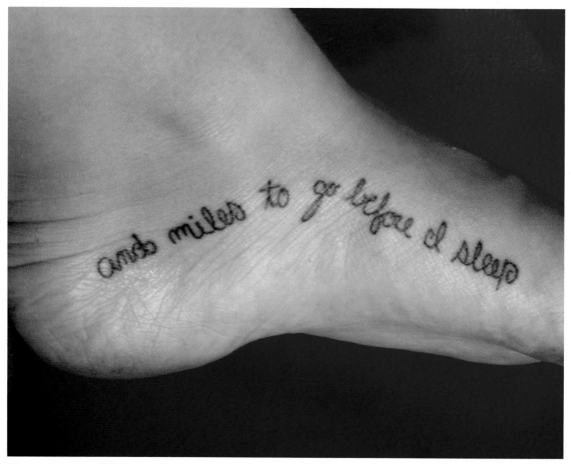

"The words are an excerpt from one of my favorite Robert Frost poems, 'Stopping By Woods on a Snowy Evening.' They are the last two lines, which imply the whole final stanza ('The woods are lovely, dark and deep / But I have promises to keep / And miles to go before I sleep / and miles to go before I sleep.') The tattoo is a challenge to me not to be lured in by the beautiful dark 'woods' of drugs, drinking, bad decisions, laziness, non-action, or self-destruction and self-annihilation. I know full well the pull of the beautiful darkness but in this tattoo I am firming my resolve to follow a higher path."

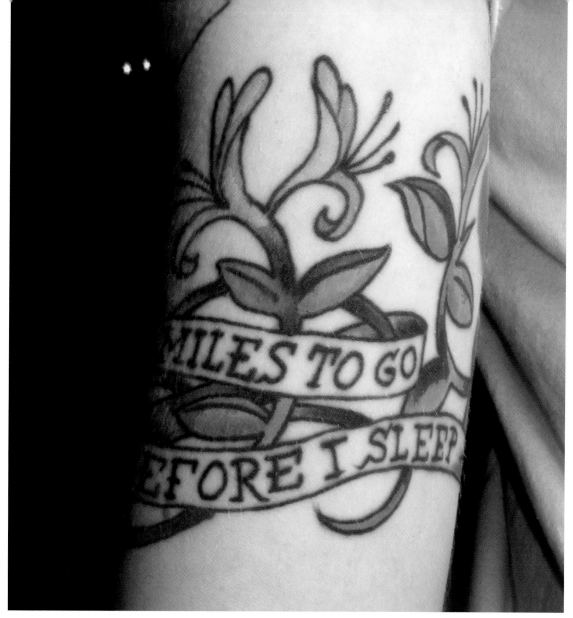

"I had a moment of revelation when I read this Robert Frost poem and wanted to get this tattoo right afterward. To me, the message of the poem was about living in the moment in the most intense way, but then, at the end, realizing there is so much more to live for and to accomplish in the future. It made me think: have I really lived every moment of every day, what would I regret not having done, what promises have I not fulfilled yet?"

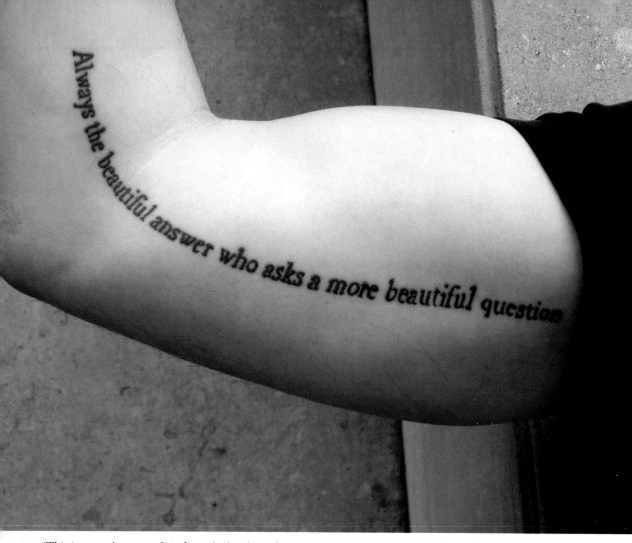

"This is my only tattoo. It is from the last line of e.e. cummings's introduction to his last book of poetry. The typeface matches the book exactly; it is the only typeface he ever used. I got the tattoo some time after a series of crises in my life: I lived two blocks north of the World Trade Center and saw way too much on September 11th. Shortly thereafter, two people who were very close to me died, and then I had a major health crisis and was in a coma for two weeks. Once this happened it helped me understand my sensitivity to traumatic events. I have a hard time living with questions; e.e. cummings made me feel comfortable living with questions. This tattoo reminds me every day that this is how I have to live my life, to stay away from unhealthy things. I was very scared at first because it's permanent, but I've never regretted having it."

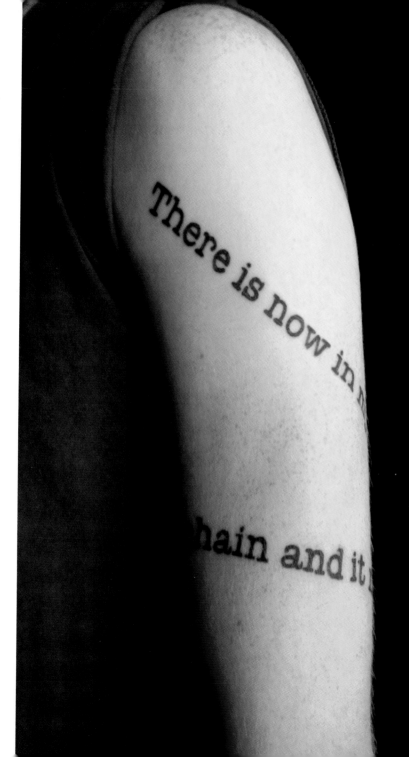

"This is the last line in the play *Equus* by Peter Shaffer. 'There is now in my mouth this sharp chain and it never comes out.' It is spoken by the character who plays a child psychiatrist who has been treating a teenager who committed criminal acts. The doctor refers to taking on his patient's pain, thereby allowing the patient to forget the pain; it has become the doctor's burden. I believe that negative energy is not destroyed, it is just transferred from one source to another. I have always been interested in criminal psychology and criminal profiling. I chose American Typewriter as the typeface for this tattoo because it is so distinctive and I felt it fit the character of this British play; I thought it was a way of having it cross over to fit my experience."

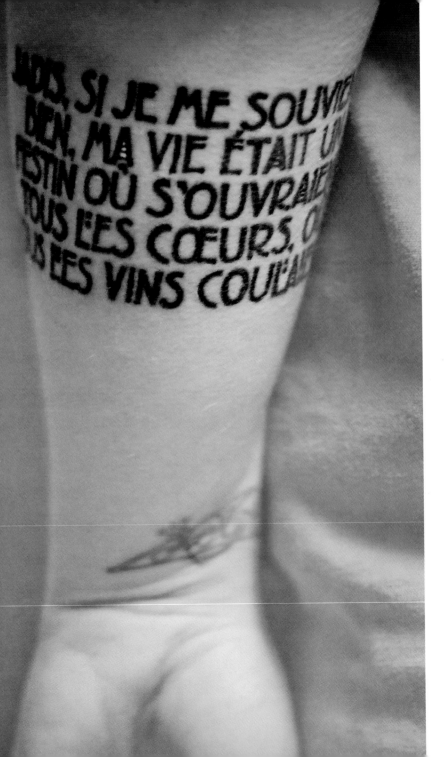

"This particular quote from Rimbaud's *Une Saison en Enfer* has been a favorite of mine since I have been a teenager. The words evoke a sense of childhood, of innocence, of a time when life was easy and uncomplicated. The words are beautiful, and I think it makes sense to have beautiful things marked on your skin. The full text in French is, 'Jadis, si je me souviens bien, ma vie était un festin oú s'ouvraient tous les coeurs, oú tous les vins coulaient.' The translation I like best is, 'Once, I remember well, my life was a banquet where all hearts opened, and all wines flowed.' But no English translation matches the lyricism of the French. I chose the typeface Rennie Mackintosh because it is roughly from the same time period as the poem, and it had the added attraction of having a Scottish origin, which appealed to my sense of nationalism."

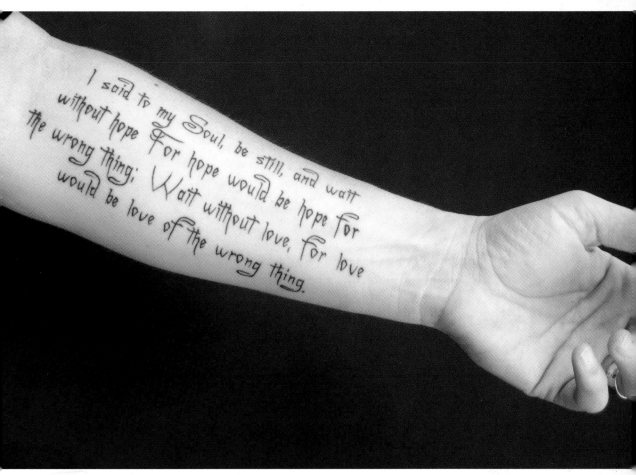

"I got this tattoo on my birthday, inspired by *Body Type*. This passage, from the third verse of 'East Coker,' the second of T. S. Eliot's *Four Quartets*, is a meditation for me. It is a guide which can be read at all stages of life."

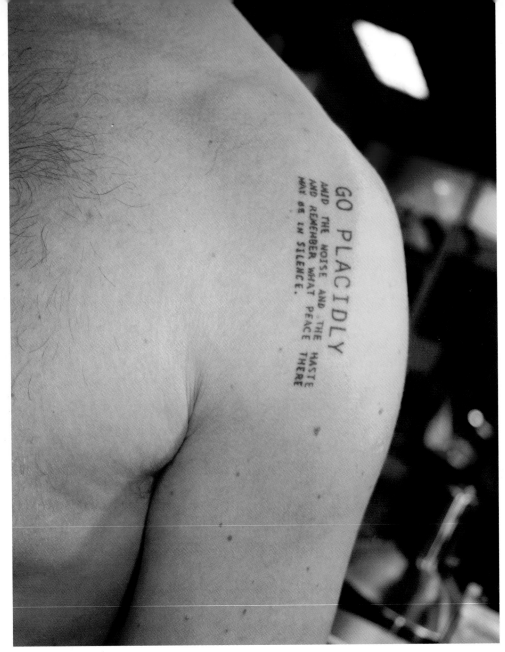

GO PLACIDLY
AMID THE NOISE AND THE HASTE
AND REMEMBER WHAT PEACE THERE
MAY BE IN SILENCE.

These are the opening words from the prose poem "Desiderata," attributed to Max Ehrmann. The simple sans serif typography is a good match for the sentiment of the text.

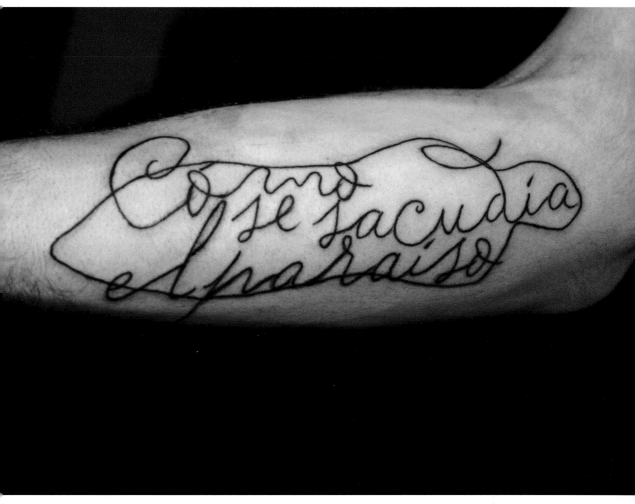

The literal translation of this idiomatic expression is "What's shaking in paradise."

Juan Rulfo, a Mexican realist author, uses this phrase in his book *Pedro Paramo*. "Vio cómo se sacudía el paraíso dejando caer sus hojas: 'Todos escogen el mismo camino. Todos se van.' Después volvió al lugar donde había dejado sus pensamientos. Susana dijo. Luego cerró los ojos. Yo te pedí que regresaras . . ."

The English translation is, "That was the last time I saw you. As you went by, you brushed the branches of the Paradise tree beside the path, sweeping away its last leaves with your passing. Then you disappeared. I called back after you 'Come back Susana!'"

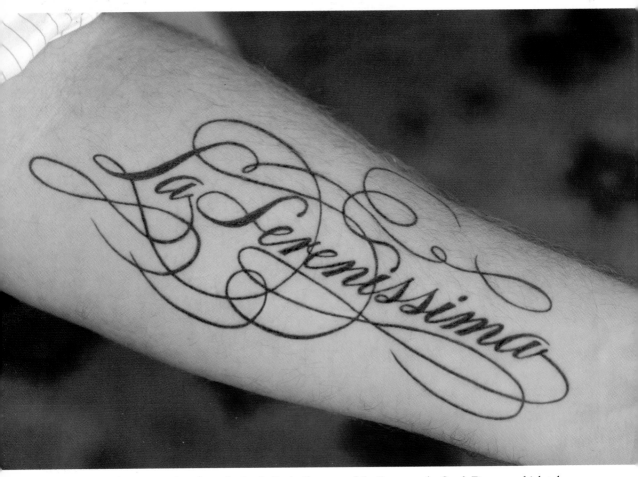

Above: "This phrase was taken from the book, *In the Company of the Courtesan*, by Sarah Dunant, which takes place in Venice during the Renaissance. The Turks competed with the Italians for shipping, and there was tension on the water, because there might be war. I am a very intense designer, and the tension on the surface fits my personality. 'La Serenissima' is a term used for Venice. I based the tattoo on the typeface Burgess, which has a lot of ligatures. I customized it myself. This is my only tattoo."

Right: "My tattoo is the thirteenth and final verse of Wallace Stevens's poem, 'Thirteen Ways of Looking at a Blackbird.' When I studied literature in college, I loved this poem, and as I got older, I felt that it was about inevitability and contradiction, that something can feel true even if it is not factually true; things become what they are supposed to be. I knew I wanted a typewriter font; I found this one on the Internet."

XIII
It was evening all afternoon.
It was snowing
And it was going to snow.
The blackbird sat
In the cedar-limbs.

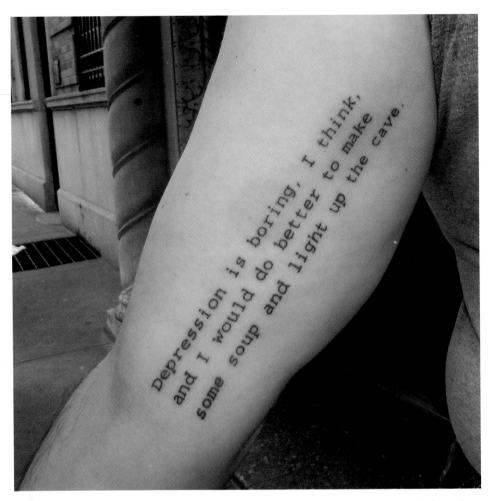

"A friend showed me *Body Type*, and I also went to the exhibition of the photography from the book at Cooper Union, which intrigued me. My boyfriend gave me a birthday card saying he'd pay for a tattoo, and I remembered this particular part of Anne Sexton's poem, 'The Fury of Rainstorms,' which I had read as a voiceover for a friend at film school. I had periods of depression in college, like Anne Sexton, and I identified with the poem, not in a fake, cheery way but in a more realistic way about making the best of it. I like the language of it, especially the notion of lighting up the cave rather than making a nicer place of it."

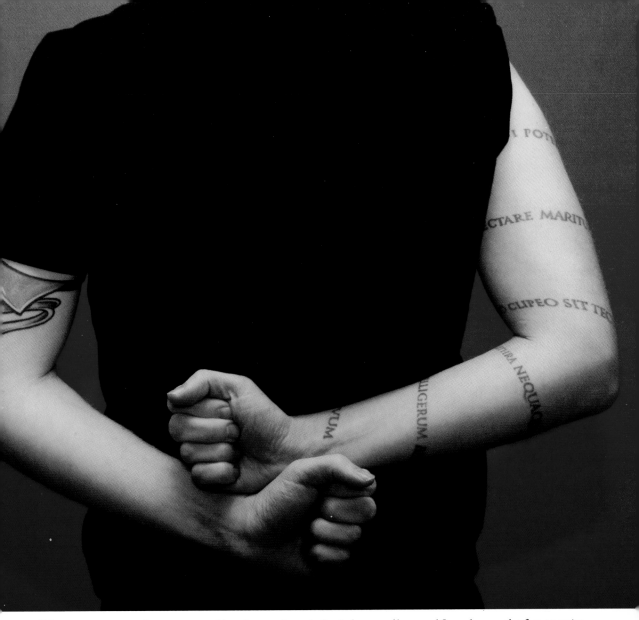

"The text on my arm is 1000 years old and was written in Latin by a monk named Saxo; he was the first to write down the Norse/Danish Viking sagas that had previously only been transmitted orally. It appears in the book *Saxo Grammaticus*, which tells the story of the Danes (I am Danish). Roughly translated, it means, 'If I should see him, Frigg's horrifying husband [Odin, the god of the kings and the god of death], then he shall not, no matter how much he seeks shelter behind horse and shield, get out of Lejre [an old and famous Viking capital] alive. No one can deny me the right to slay a wargod in battle.' The main character in this saga bears the same name as me (Bjarke). The text reminds me of what really defines us as individuals in times of pressure . . . it gives me strength."

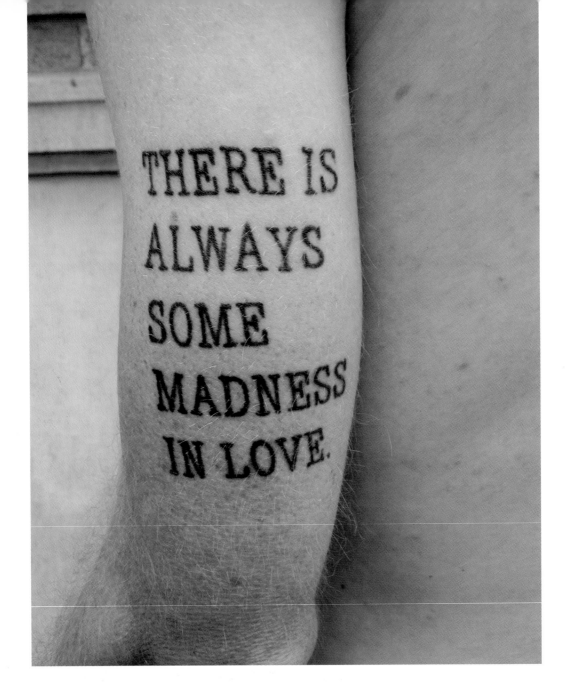

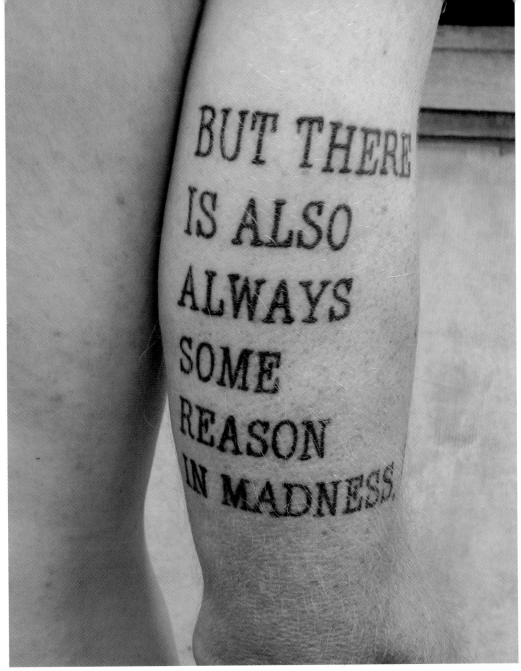

"This pair of tattoos quote from Friedrich Nietzsche's *On Reading and Writing*. I chose this text because I needed to transition out of a path that I was not cut out for. I decided against pursuing an MBA. The tattoo was a guarantee that I would never become that person."

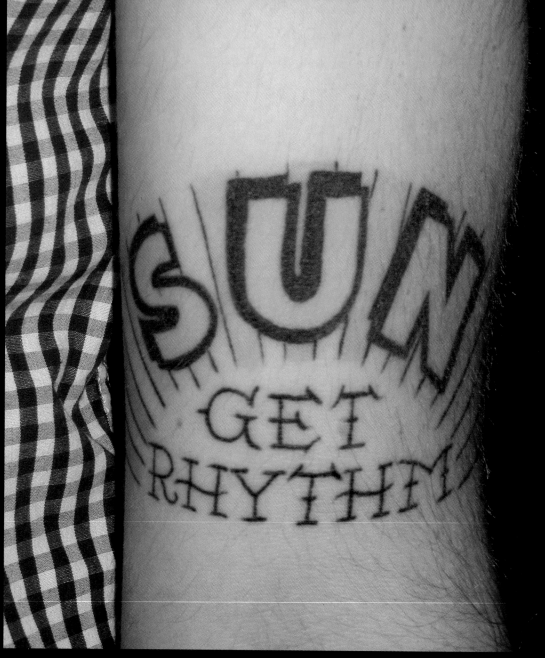

Johnny Cash recorded with Sun Records ("Where Rock 'n' Roll was born!"); this tattoo is a tribute to his album, *Get Rhythm*, first recorded in 1956.

*F*OUR:
*M*USIC & *L*YRICS

HOW MANY OF LIFE'S IMPORTANT MOMENTS are captured by a
song or by a musical artist or group that touches our souls forever?
The transformative power of music and lyrics to lift our spirits despite
tribulations, to console us after a failed relationship, to commemorate
an endless love, to free us from the bonds of convention, to allow us
to imagine another path in our lives . . . these are the emotions that
motivate the wearers of these "lyrical" tattoos.

Imprinting the songs that have moved us and changed our lives onto
our skin further empowers us. These musical marks isolate and elevate
a special moment in time, deepening its meaning.

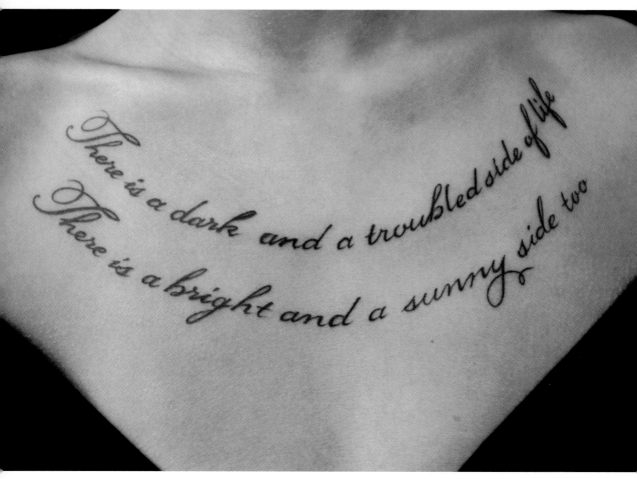

Above: "I love the Carters. I must have listened to June Carter's version of *Keep on the Sunny Side* every day for a few months straight. I hum it almost daily, it's almost a mantra for me. I also knew I wanted to get a chest piece and I wanted to keep it light and feminine, and I do love type. The *T*s are Chopin Script and the rest of the text is in Bickham Script at 80 point."

Right: "This is from the Lou Reed song, 'I Believe in Love.' I love music and I love red. I chose the typeface Typo Upright from the Internet. Three months after I got this tattoo I was diagnosed with breast cancer and two months later I found out I have secondary cancer in my bones, which is incurable. I live life now; that's my job. I have up to eight years to live, so everything in my life has been put into sharper focus and my priorities have changed. Now, looking back, my tattoos seem almost like a premonition, 'music, music, music, it'll satisfy your soul . . . ' is a permanent marker of what is important to me and a reminder to follow my heart's desires."

"...And I believe in good times, good times rock 'n' roll
Yeah I believe in the music, music, music
...It'll satisfy your soul..."

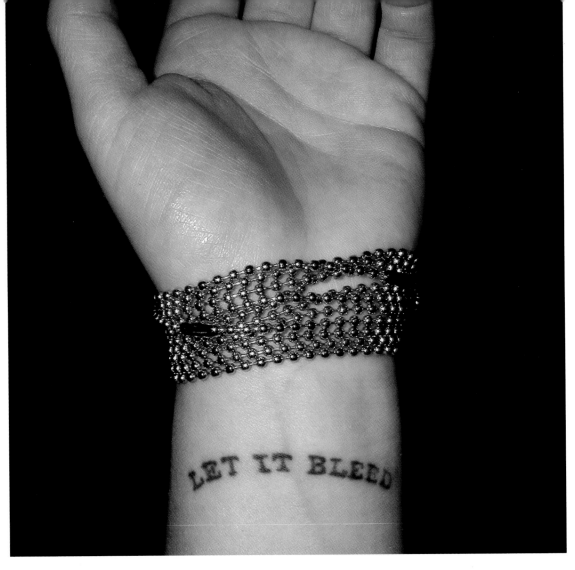

Above: "This is from the 1969 Rolling Stones album."

Right: "I found *Body Type* in Sydney, Australia, and just flipped. As a graphic designer, I'd always planned to have a large tattoo of a favorite word in a preferred font tattooed on me. Some time later, I was listening to one of my all time favorite albums—*Exile on Main St* by the Rolling Stones—and admiring the cover art, a collage of Robert Frank photographs but with art direction and typography by John Van Hammersveld. I remember when I first saw the cover in 1972, and thinking what crazy writing. In truth, it was punk well before punk was a movement. I scanned the cover into my computer in high res, lovingly outlined the type in Illustrator, and scaled it to the exact size I needed to fit my arm. I then called upon the services of my very good mate Lucky Diamond Rich (the world's most tatooed man) to set to work on inking me."

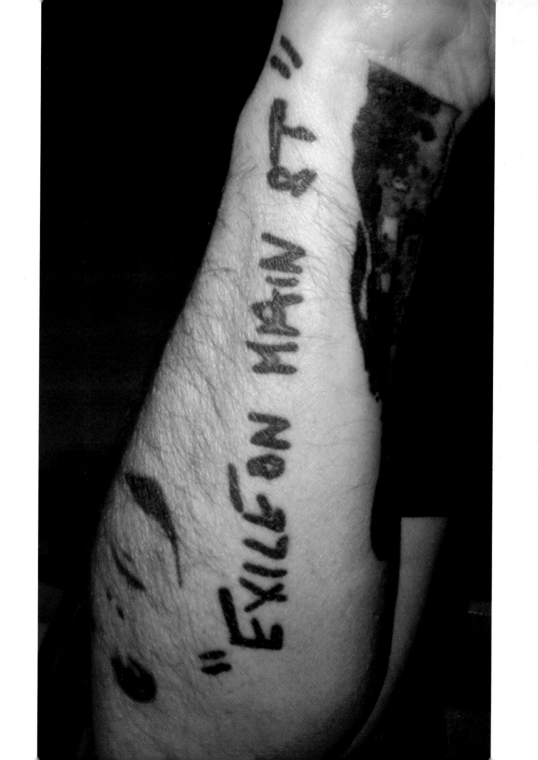

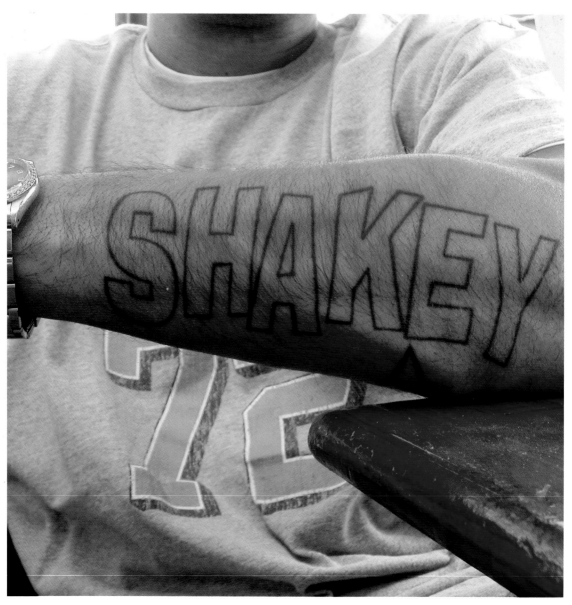

"This is the name of a record company I started in L.A."

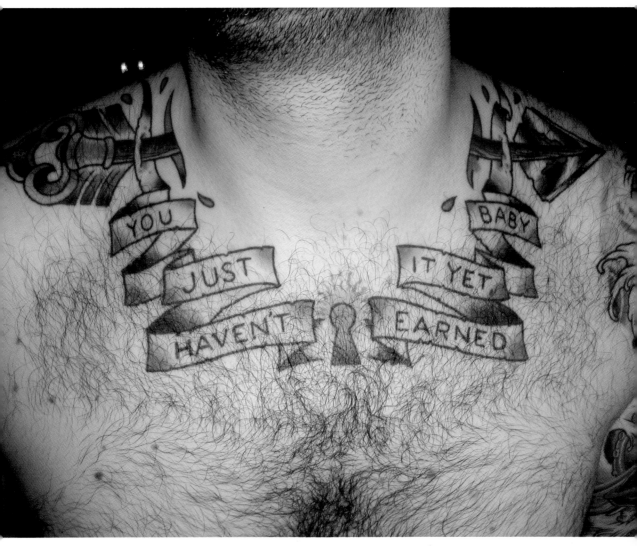

"The Smiths recorded the song 'You Just Haven't Earned It Yet, Baby'; these lyrics are about urging myself to work harder."

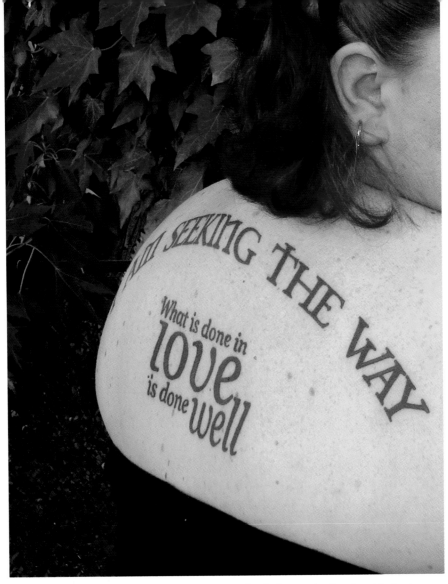

"'What is done in love . . .' is a quote from Van Gogh that my husband and I also have inside our wedding bands. Right after we got married I had a major health crisis; the tattoo was a celebration of no longer being sick and coming through it together. 'I am seeking the way,' is the last line of a song called 'Thoughts Without Words' by Shadows Fall, who often reflect Buddist ideas in their lyrics. It is about breaking free from what the world has handed you and finding out the truth for yourself. My husband designed my tattoos because I wanted him to be a part of it. 'Love' and 'well' were designed to be readable from a distance, then closer up, the full message would be visible. The top tattoo is Celtic Garamond, and the bottom is Caslon Bold Italic."

"My tattoo was taken directly from the logo of the seminal metallic hardcore band Unbroken and their 1994 album of the same title. At that time, the music was really important to me and shaped the sound of the bands I formed in that period. I still love the sentiment of the words, and they echo my feelings of regret in my own life, which is another reason I chose to get the tattoo. When I was twenty I let my first and true love go. I recently got back together with her after many years, but the time gap had been too long, and we realized we had ultimately grown apart. We tried, but failed to recapture the romantic ideal based on how we felt back then. I studied typography at university and felt a type tattoo was inevitable."

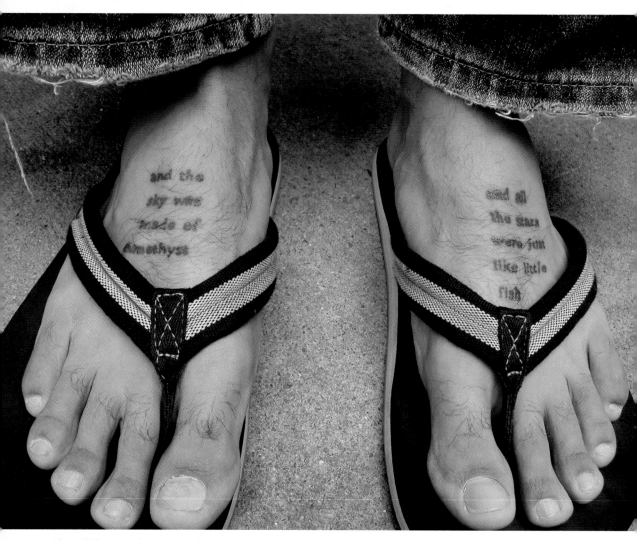

Above: "These are lyrics from the song 'Violet' by Courtney Love, which she sang with Hole, 'And the sky was made of amethyst / and all the stars were just like little fish . . .' it is a song that was always in my head. I wanted to remember a time in my life when I was a little rave kid, having fun, with no responsibilities; life was good."

Right: "Many of my tattoos are all about the Clash. These are lyrics from a song called 'Clampdown.' I grew up in a remote area with very little exposure to FM radio; it was pre-MTV. My parents had foreign exchange students living with us every summer and through a French girl I learned about the Clash. Their music seemed very noble at the time, with a social conscience. I was looking for typefaces with a punk aesthetic and I found this one in a *New York Times* magazine feature.

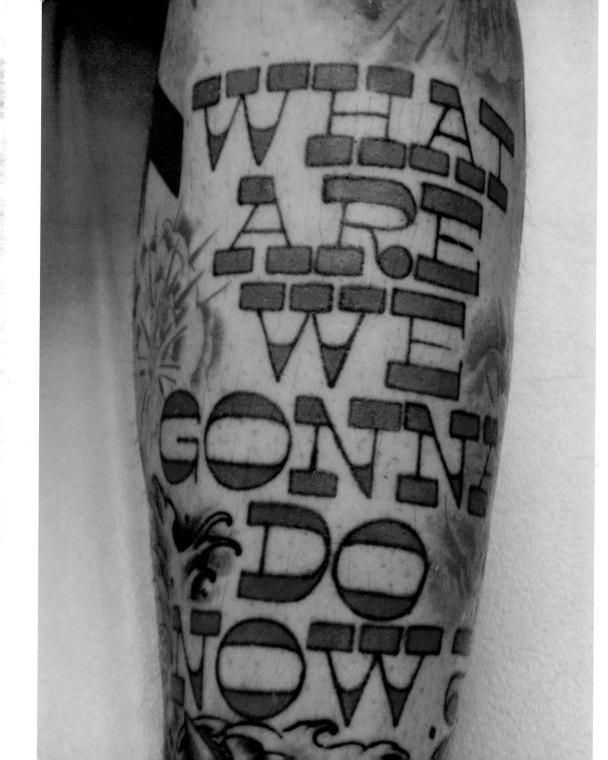

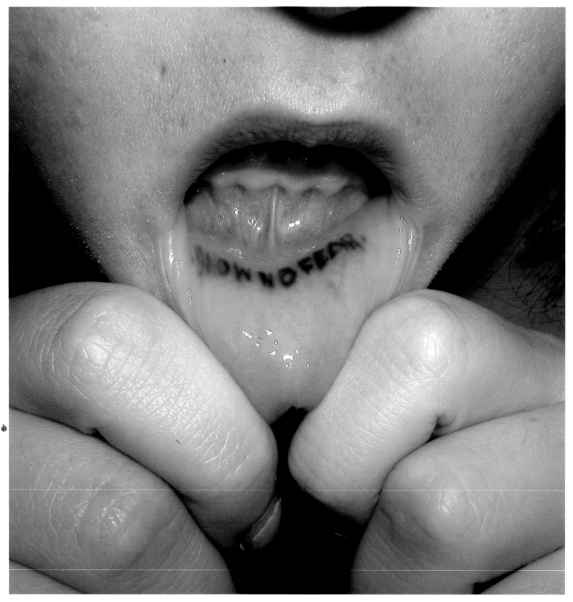

"This song lyric is from a Madball song."

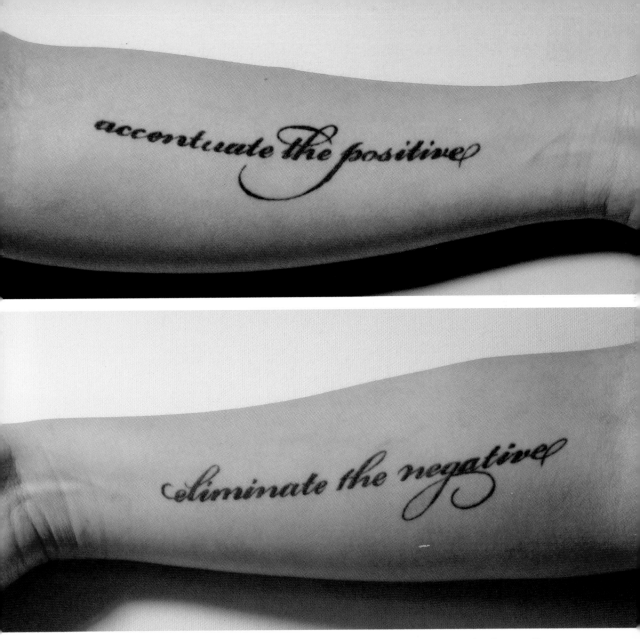

"I've been trying to be an optimist all my life. These are lyrics written by Johnny Mercer for the song 'Accentuate the Positive,' from the World War II movie, *Here Come the Waves*. My husband is a tattoo artist, and he did the words in Bickham Script. I liked how graceful it was and that it had options for the glyphs."

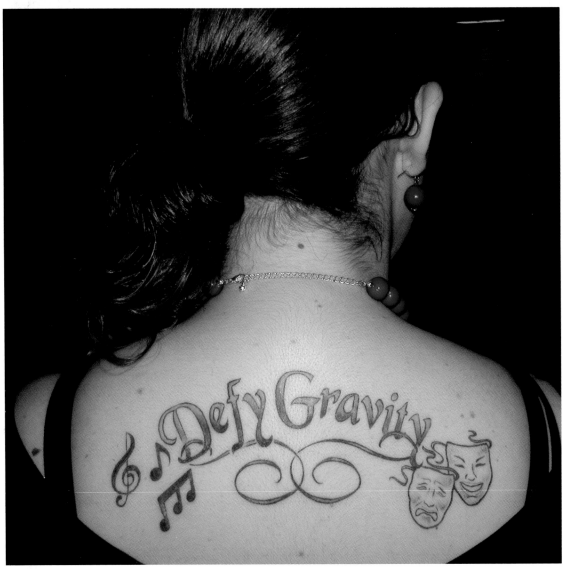

"I love musicals; they are my life. I just moved to New York City from Washington state to get into acting. The tattoo refers to the song from the musical *Wicked*. I have seen many touring companies perform the show, and this song inspires me to feel as if anything is possible."

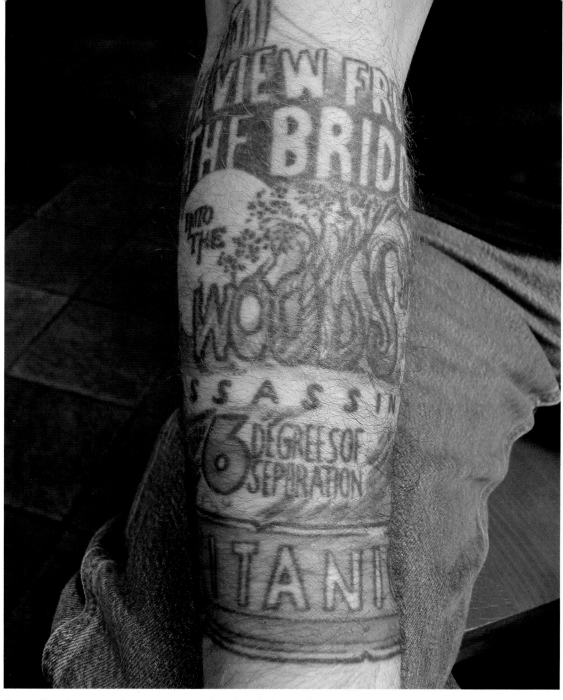

"I am a Broadway wigmaker. My tattoos are based on the logos of the shows I have worked on. It is a work in progress."

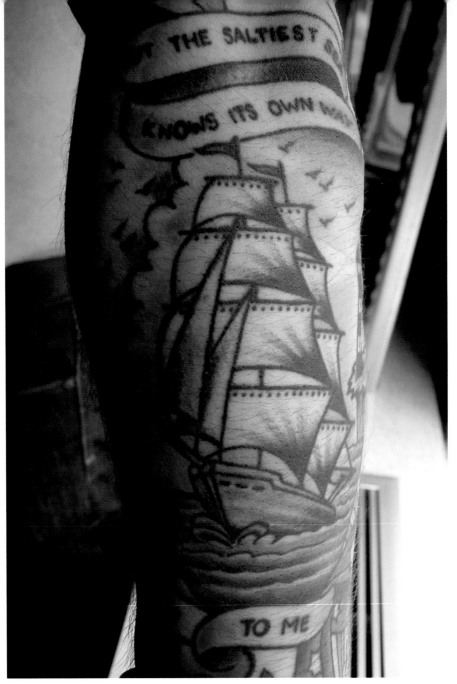

"'But the saltiest sea knows its own way to me . . .' These lyrics from a Joanna Newsom song are about starting my new life in Australia."

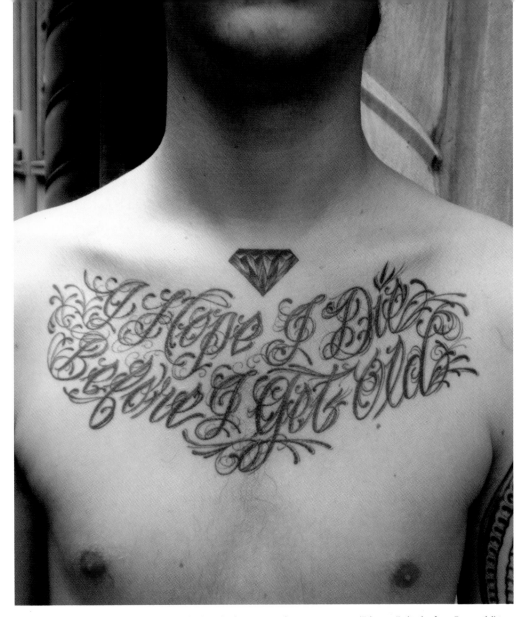

"My dad brought me up with the right kind of music and great taste . . . 'I hope I die before I get old' is a lyric from the Who's 'My Generation.' It was written about Keith Moon, the greatest rock drummer of all time. I play drums, and I have modeled all of my drumming after Keith Moon. Besides the literal meaning, it also means to stay young at heart."

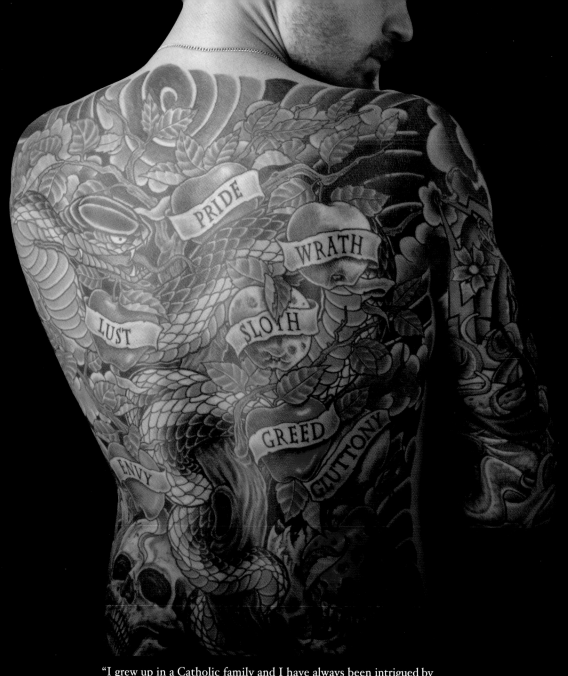

"I grew up in a Catholic family and I have always been intrigued by
the seven deadly sins . . . we are tempted every day."

FIVE: FAITH & PROTEST

DEVOTION TO A CAUSE and rebellion from a cause: these are opposite sides of the same coin. Whether we choose to embrace a set of values, or to reject them, proclamations on flesh represent our clear commitment to an idea or a religious framework.

Perhaps we wish to influence others, perhaps we only wish to declare ourselves. We have the power to publish our positions visibly with these political and religious tattoos. They may invite questions or provide answers, but we choose to wear our faith (or our lack thereof) on our sleeves precisely because it defines us.

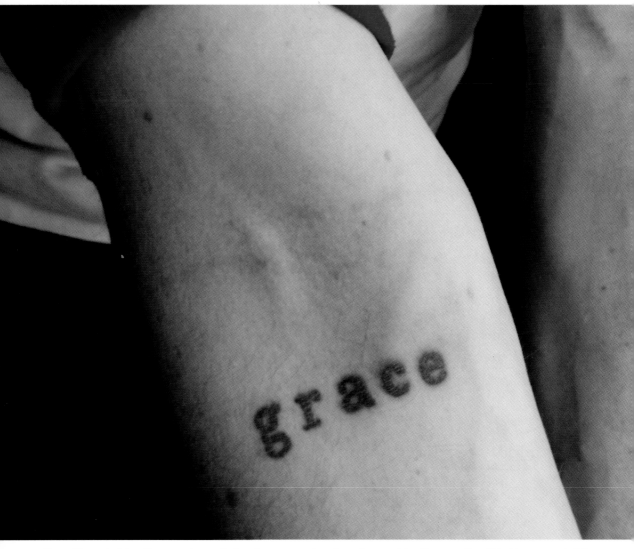

Above: "As a musician, I was on the road a lot. I was at a point where I was spiritually struggling. I had been married for twelve years and I was baffled about why I did not feel comfortable or settled. I got the tattoo because I needed grace, God's unconditional and unwarranted love. I found a typewriter font on the computer, and I opened up the letters and thickened them in Photoshop to resemble the image in my mind of an old manual Royal typewriter that I had."

Right: "The idea for my tattoo arose from the well-known biblical verse, 'One thing I know; once I was blind, now I see' —John 9:25. I decided to use the idea of the eye chart because it went well with the meaning of the text. I am a Christian and that is important to me. I got saved but for the last year I have fallen astray. The tattoo is a daily reminder to abide by the rules, to be who I should be and who I want to be."

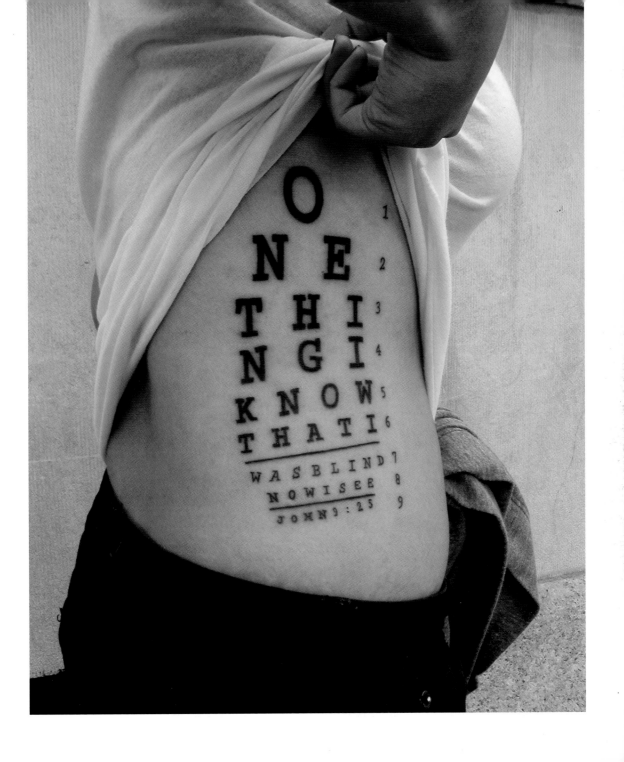

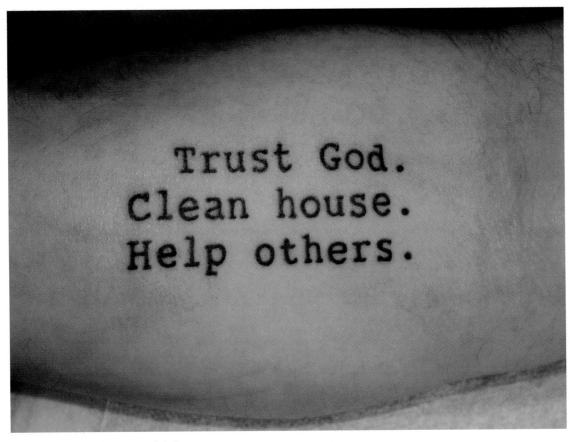

"A guide for everything in my life."

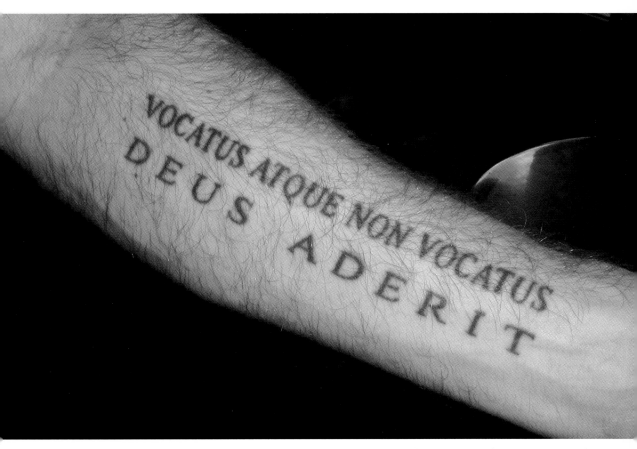

"The translation of this text varies; one version I like is, 'Whether we call for him or not, God is present.' It is from the jottings of Erasmus, the Renaissance scholar and humanist. Carl Jung had this quote inscribed over the door to his house and on his tombstone."

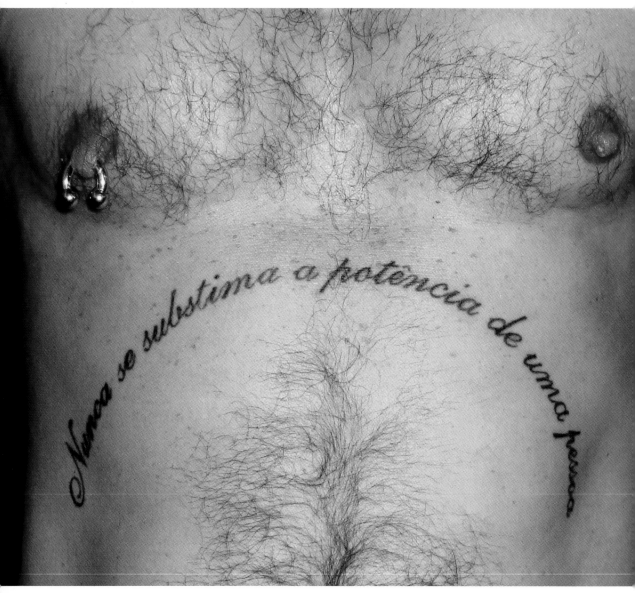

Above: "My text is in Portuguese and means, 'Never underestimate the power of one person.' To me, it means I can change things if I want to. I don't need to be frustrated the rest of my life. I got the tattoo in Rio, and decided to get it in Portuguese because it would be more mysterious."

Right: "I have always had faith in living my life by trusting in whatever may happen: that is serendipity."

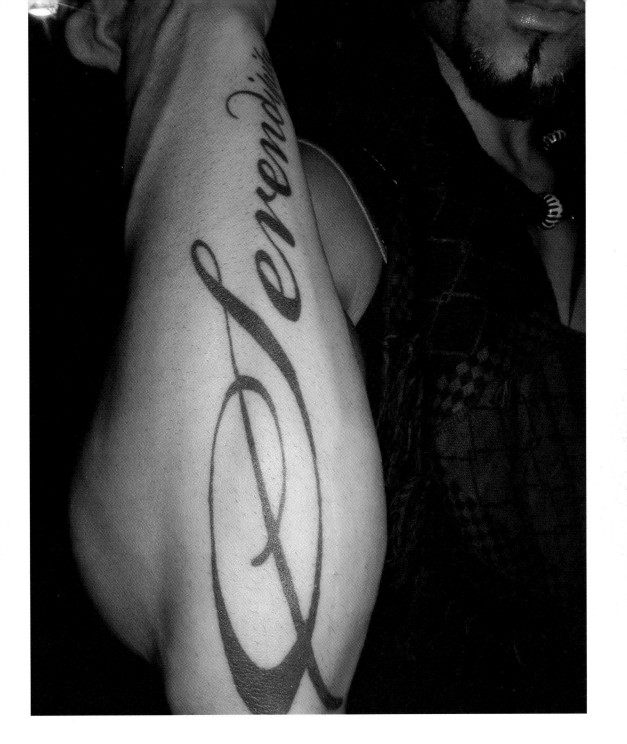

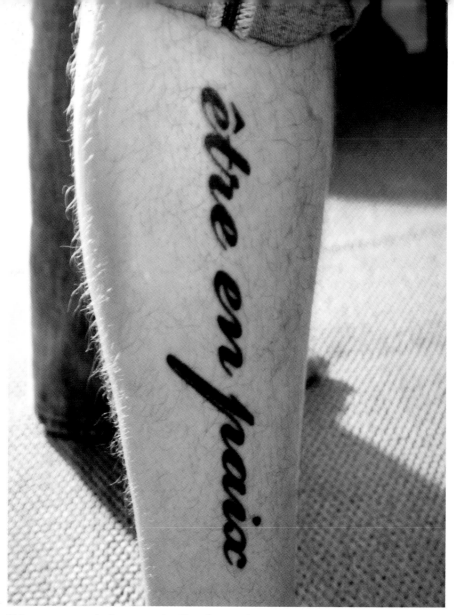

"My tattoo means 'to be at peace' in French. I was born in America but always identified with my French ancestry. I surprised my identical mirror-image twin brother with it on our twenty-first birthday. The words are a kind of mantra to me; I found them in a French dictionary when I was trying to brush up on my vocabulary. Anytime things are particularly stressful, I think about what it means, and it helps calm me down. It has a double meaning, because it is also a phrase that you might find on a gravestone. My friend is a graphic design student, and he showed me different typefaces. I chose Edwardian Script Bold in lowercase."

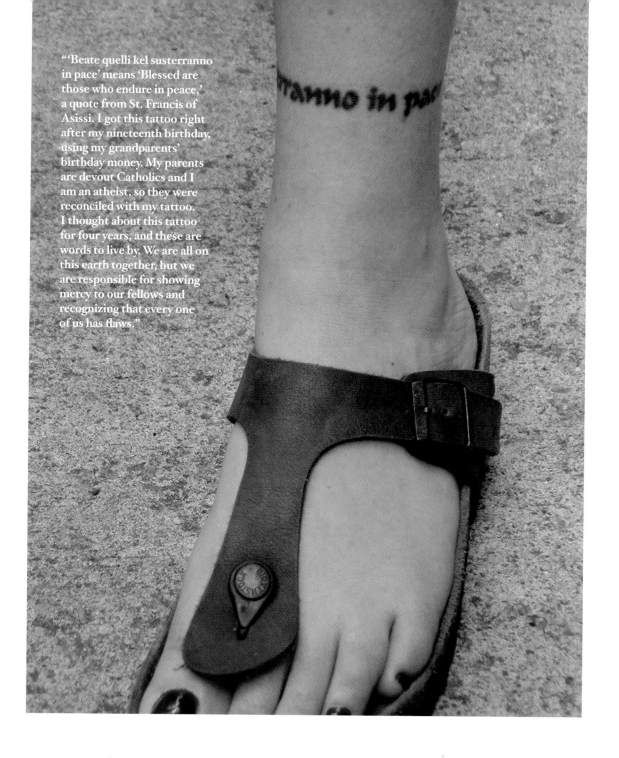

"'Beate quelli kel susterranno in pace' means 'Blessed are those who endure in peace,' a quote from St. Francis of Asissi. I got this tattoo right after my nineteenth birthday, using my grandparents' birthday money. My parents are devout Catholics and I am an atheist, so they were reconciled with my tattoo. I thought about this tattoo for four years, and these are words to live by. We are all on this earth together, but we are responsible for showing mercy to our fellows and recognizing that every one of us has flaws."

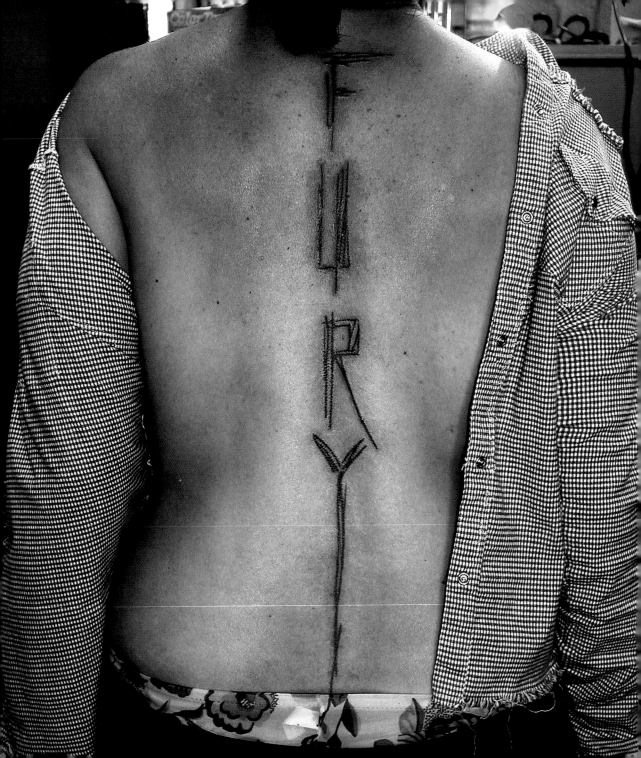

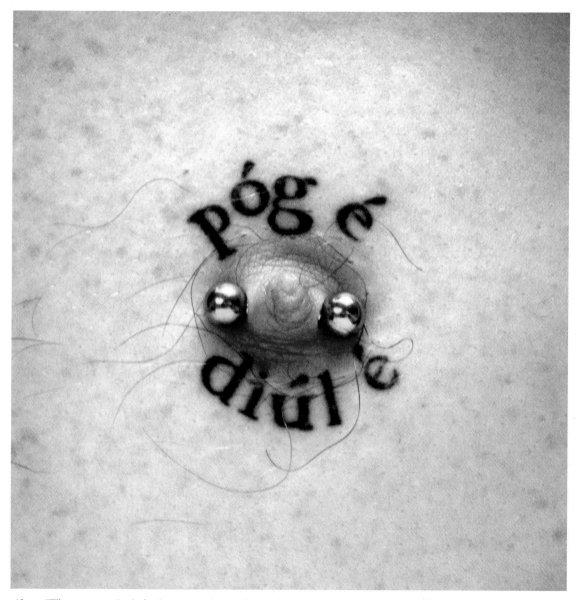

Above: "The tattoo is Irish for 'kiss it, suck it,' referring back to the Celtic practice of nipple sucking as a means of greeting, the equivalent of cheek kissing today. It is one of a number of artworks where I embrace my Irish identity while rejecting my Christian upbringing. In pre-Christian Ireland it is a handshake, in Christian Ireland it is an outrage and an abomination. It is written in a customized font based on a traditional Celtic manuscript."

Left: A large, handlettered word customized to the back, expressing an explosive emotion.

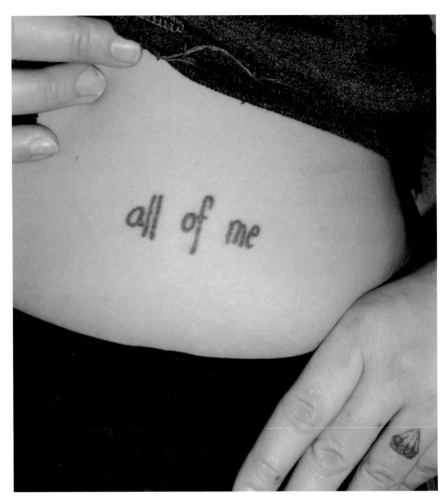

Above: "I have a lot of tattoos; each marks a different time period and different relationships. I was a gender studies major, with a feminist approach, and I want to feel proud to the edges of my body as it is. 'All of me' implies 'take it or leave it.' I handlettered the text, and I got the tattoo on my hip because it is an insecure spot for me."

Right: "I got this tattoo in Italy but I designed it in English because I wanted it to be readable here, where the animal rights movement started. I became a vegetarian first, and now I am a vegan."

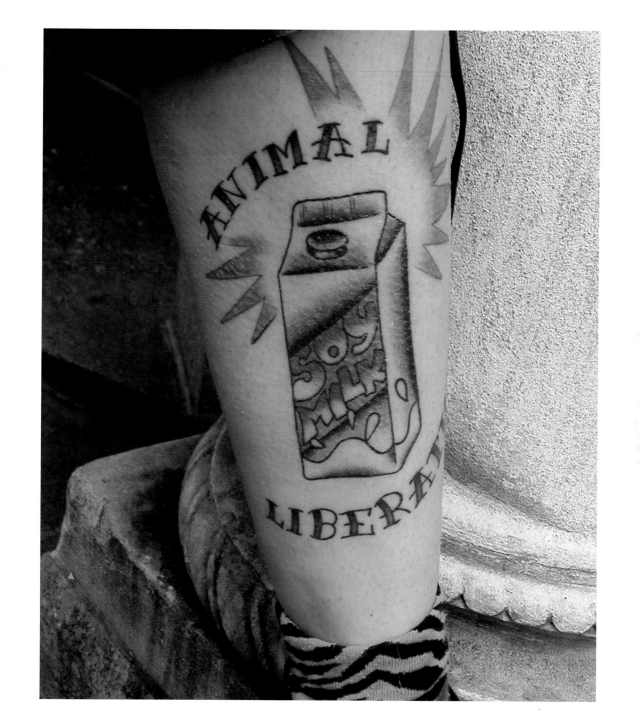

Above: A tribute to the new president of the United States.

Right: "Prior to Obama's inauguration, I made a lot of long-overdue changes in my life. I was aware of this quote from Corinthians 13:11; I probably heard it first from a rapper. It was pertinent to what I was thinking about growing up and moving forward with my life. Then I heard it in Obama's speech. I knew I wanted a tattoo of a meaningful quote, and I took it as a sign. My dad is a big Republican and very conservative, but I just liked the guy (Obama)."

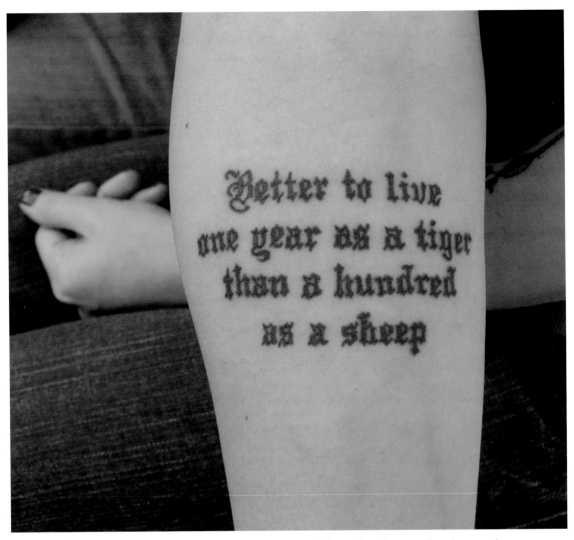

"I found the quote from Madonna. I work for a tattoo artist and I have a lot of tattoos, but the ones that mean the most to me, like this one, are the most visible. It represents the way I live my life—I am very limitless and adventurous—I don't want to waste a single day."

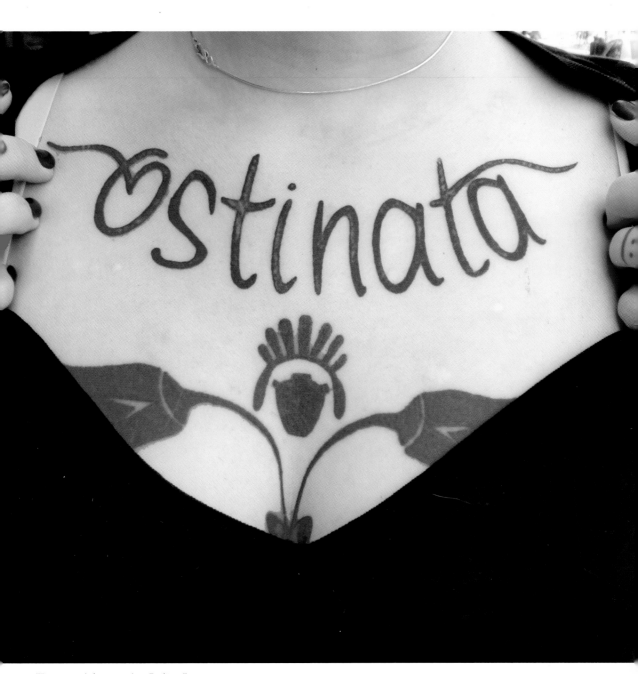

"It means 'obstinate' in Italian."

"The words 'Only keep quiet' are taken from a recorded dialogue with Ramana Maharishi, a 1930s-era Indian sage. If there is one theme, it is that the world is a complicated place and there is a lot of pain . . . people just want to be safe. These three words are the distillation of everything."

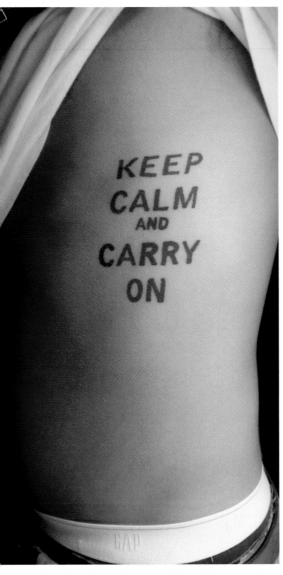

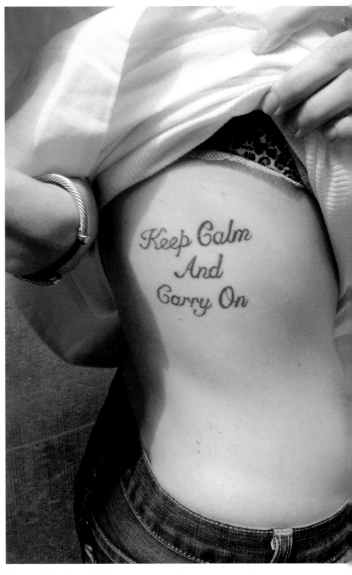

Top right: "I saw the poster 'Keep Calm and Carry On' on a friend's wall; it made so much sense to me because I had issues with anxiety. I convinced my brother to get the same tattoo."

Top left: My sister told me the story behind the phrase; it was on a poster issued by the British government in 1939 to calm the people's fears prior to WWII. I thought it was a cool story and something good to live by. Also, I never get upset when other people are freaking out. I chose the typeface to look like the original poster."

"This goes back to my relationship with my mom. My parents divorced when I was four. She gave me tough love growing up because that's how she was raised. Now I understand her."

SIX:
DEEPLY FELT

STRONG PASSIONS AND EMOTIONS are the source and inspiration for many typographic tattoos. The specificity of words provides a powerful way to express our beliefs. Who are we and why are we here on this earth? As human beings, we cannot help but seek the answers to these eternal questions, each in our own way.

Tattoos conveying deeply felt belief systems span a vast array of convictions: from selfishness to selflessness, from self-abnegation to self-celebration, from hope to despair, from a longing for purity to the acceptance of chaos. These marks of philosophical musings represent those who have found the answers and those who still seek them.

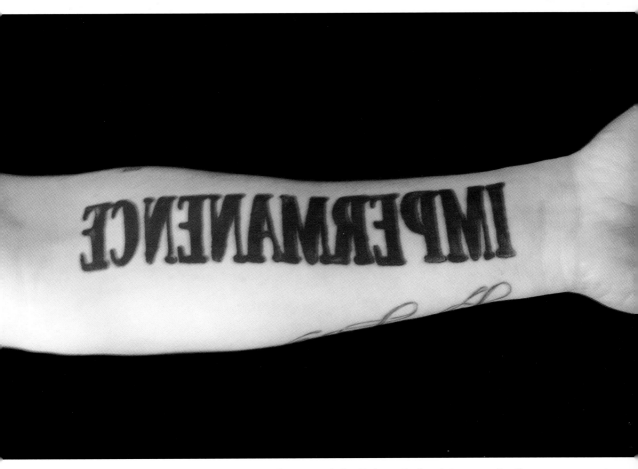

Above: "I've led an intense life, one of extremes. When I traveled to India and other Asian countries, I was impressed by the Eastern philosophy and religions, and their belief that life is change. I was feeling stuck in a rut, and wanted to see what the next chapter of my life would be, so it was a very liberating feeling. It is a strong concept, so I wanted the letters to be bold and prominent. They are in reverse because it is only when you look at things in an unusual way that you think more about them. I was able to make the changes I needed to make only when I really looked at myself in the mirror.

Left: These tattoos are all related to the creation myths of the Maori, a Polynesian people with a language similar to Hawaiian and Tahitian. They are the indigenous population of New Zealand. Papatuanuku is the great earth mother. Whanaungatanga means kinship.

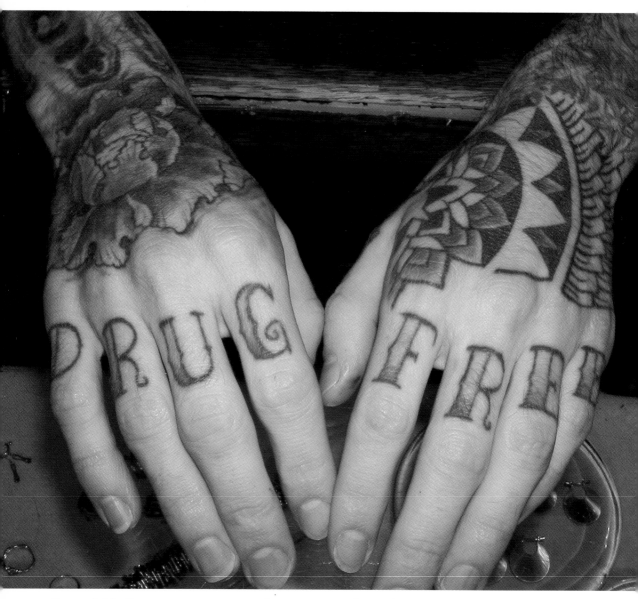

Above and right: Recovery tattoos are among the most common forms of typographic tattoo. The "triple-x" or "straight edge" movements are the means by which many people declare their commitment to staying away from drugs, alcohol, and promiscuous sex. Some tattoos in this vein are the Serenity Prayer, and phrases such as "Hold Fast" or "Poison Free."

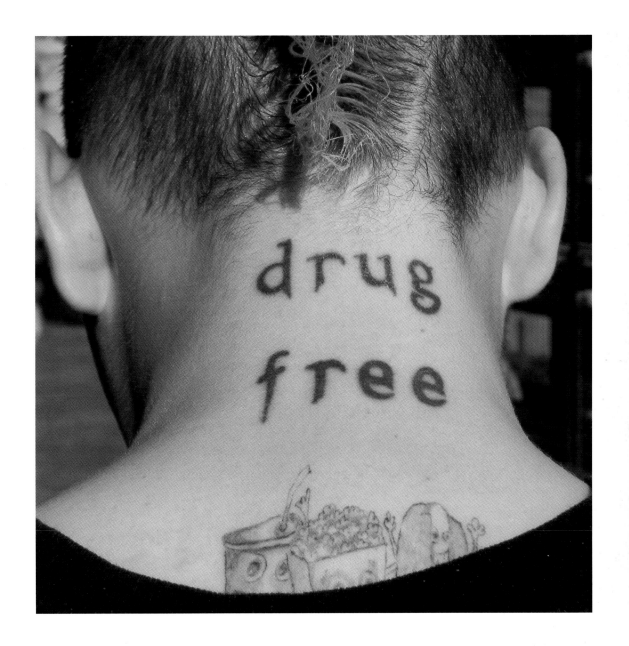

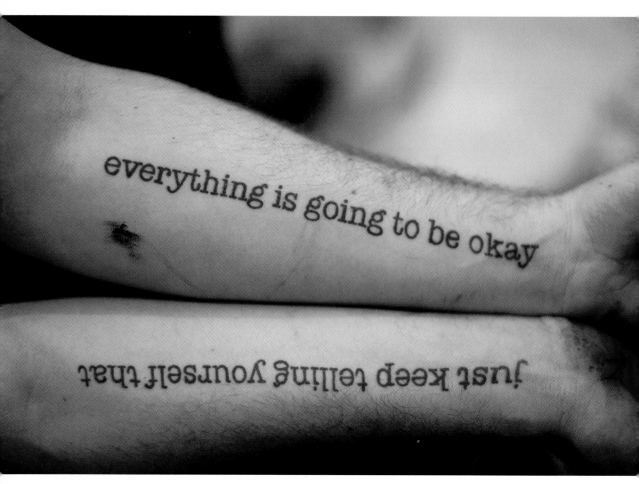

"These are my own words, to remind me to calm down and take it a little more easy. It's a tattoo about balance. I was getting dizzy spells from anxiety, but since I got these tattoos it has gone away. I chose American Typewriter as the typeface because I love typewriters in general."

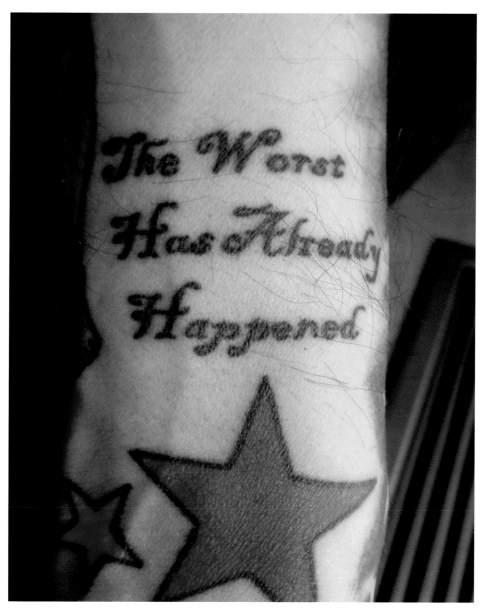

"I wrote this. And I am hoping it's true."

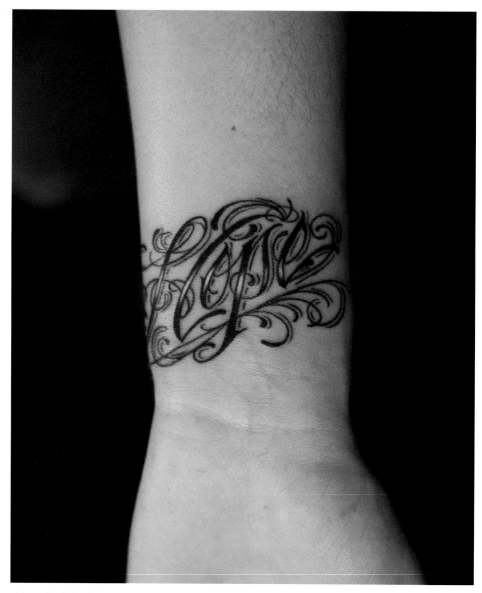

Above: "I didn't have that much luck growing up, but I have always considered hope to be my own personal religion. It's a constant reminder to stay positive and hope for the best."

Right: "This tattoo is old-school Americana, 'Sailor Jerry' style. It is good to always have hope."

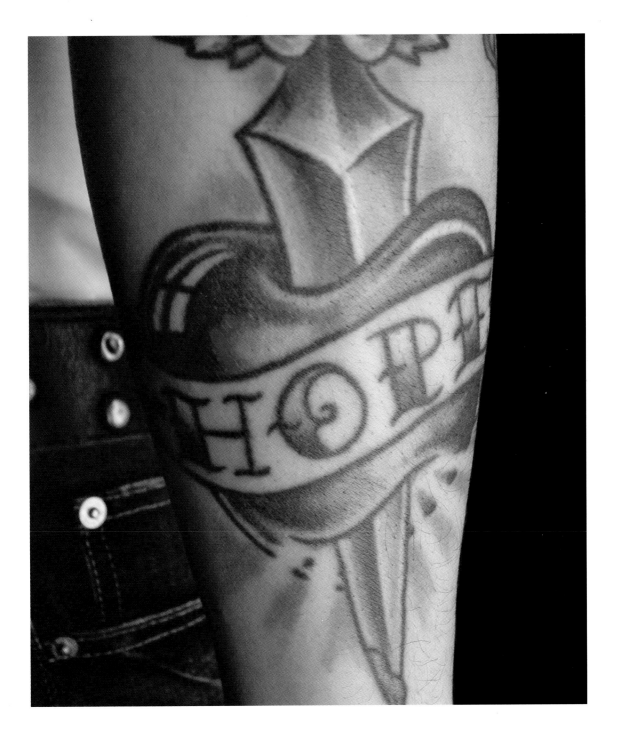

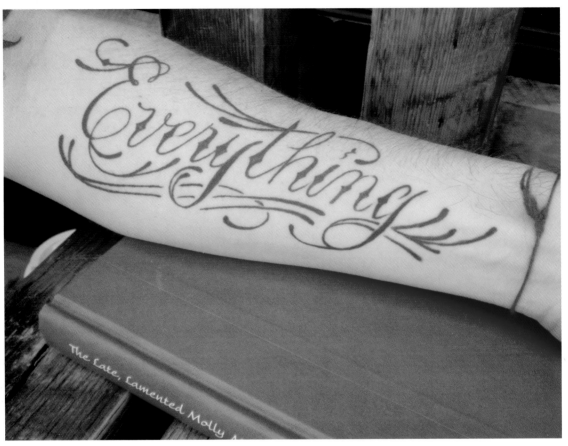

"When I had the idea for 'Everything,' I was deeply and madly in love with an incredible man . . . he was not in love with me. The word 'Everything' came from every love song which described what I was feeling. I wanted everything and I was willing to give everything to have it. I booked the tattoo appointment, but had to wait two months (I am patient). By the time I actually had the word tattooed on my arm, the incredible man had magically changed his mind and had fallen in love with me."

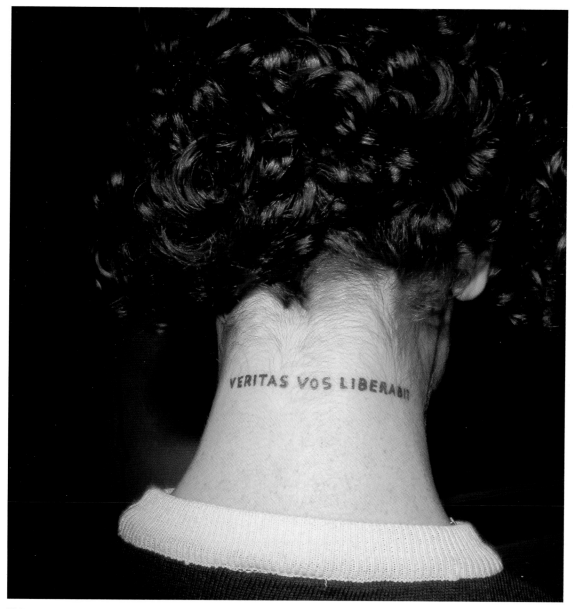

"My tattoo means 'Truth is Freedom.' I never studied Latin but I hung out in the Latin Club in college. This is an overall mantra that bleeds into all areas of my life. I strive to make the thought and the action as pure and unpolluted as possible. When people ask about my tattoo, I like the fact that it makes them consider what the meaning might be. I chose Gotham Medium because it is simple, clean, and strong, but it can also recede; the geometry is really beautiful."

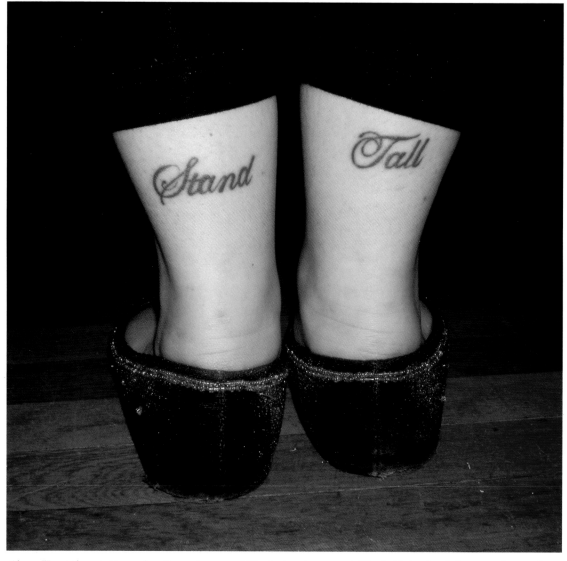

Above: "I got these tattoos when I was sixteen, a difficult time in anyone's life. In high school there are always a lot of bad influences and I never went with that whole party/drinking crowd. I live a stright edge lifestyle and I wanted to always remind myself to stand tall and stand up for what I believe in. I based the tattoo on Edwardian Script but I had the artist modify the type a little."

Right: "I went through a bad breakup and shortly thereafter, I had a near-death experience where I was rushed into surgery. Afterward, I got this tattoo, 'Sin el dolor y amor en la vida no vivas la vida,' which means, 'Without pain and love in life you don't live life.'"

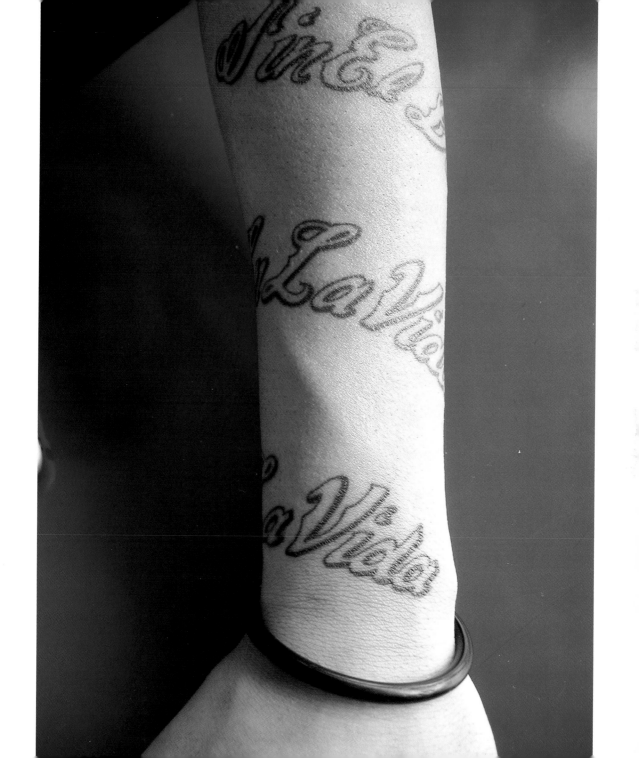

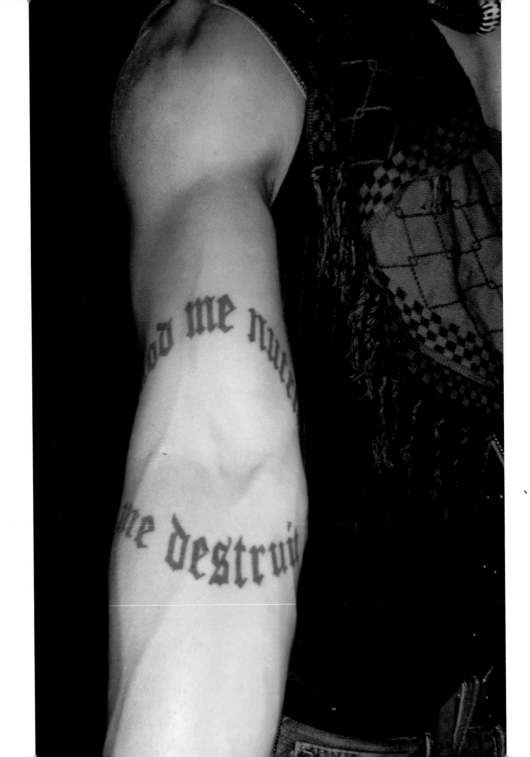

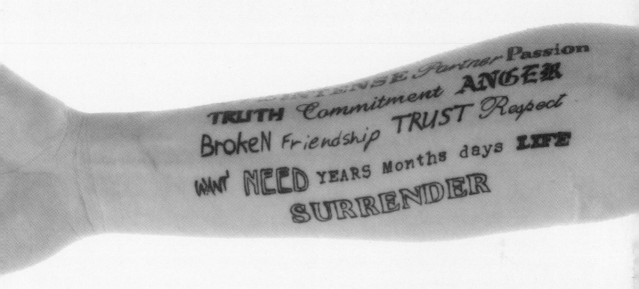

Above: "I am a Pacific mountain bike racer. After an accident which left me confined to a wheelchair, and then the end of a long relationship a few months later, there were a lot of highs and lows, a lot of learning . . . the words came from that; they are life lessons that came from very strong feelings and emotions. I sorted through the words, and a friend who had ten thousand fonts helped me find the fonts to match the feeling of each word. The fact that they are there reminds me to think about these things and helps me to deal with them."

Left: In Latin, "Quod me nutri, me destruit" (What nourishes me, destroys me).

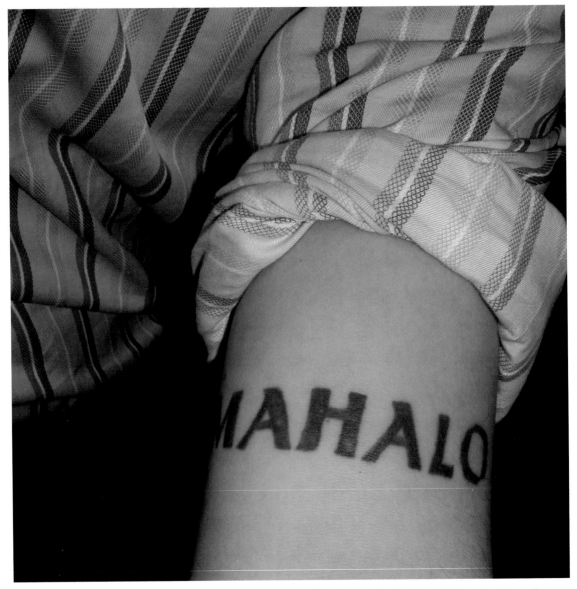

"This word means 'thank-you' in Hawaiian. I am counting my blessings and being thankful for what I have."

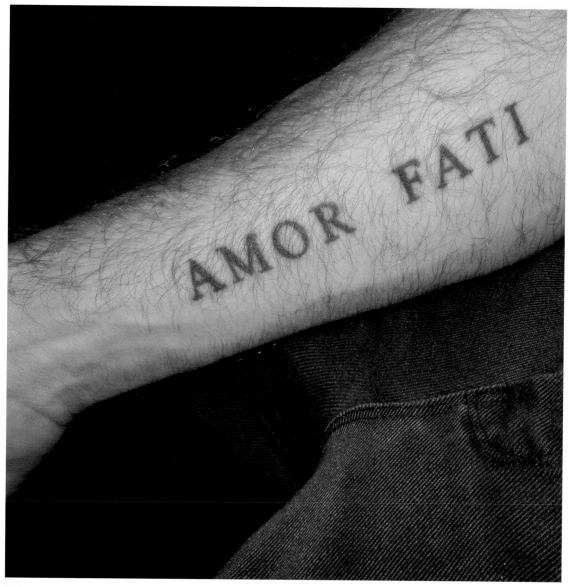

"This tattoo means 'love your fate' in Latin."

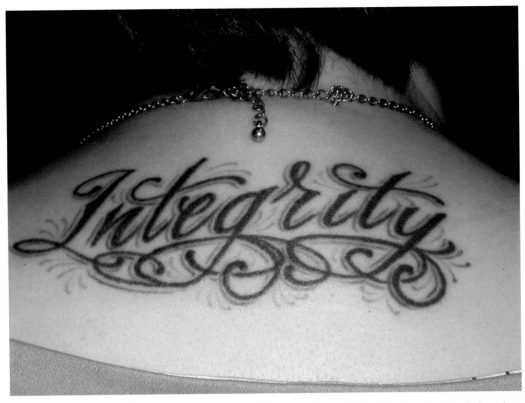

Above: "Integrity has always been an important word for me . . . it is a principle I strive for. People have lost the meaning of it. My whole life I have tried to maintain my personal integrity, but it's been a real struggle. There are so many ways to lose it."

Right: "As an artist, the word represents my artistic integrity, but also, so few people have it. Your word is your bond, but only you can give away your integrity. Integrity has always been a key concept in my life; it's how my daddy raised me."

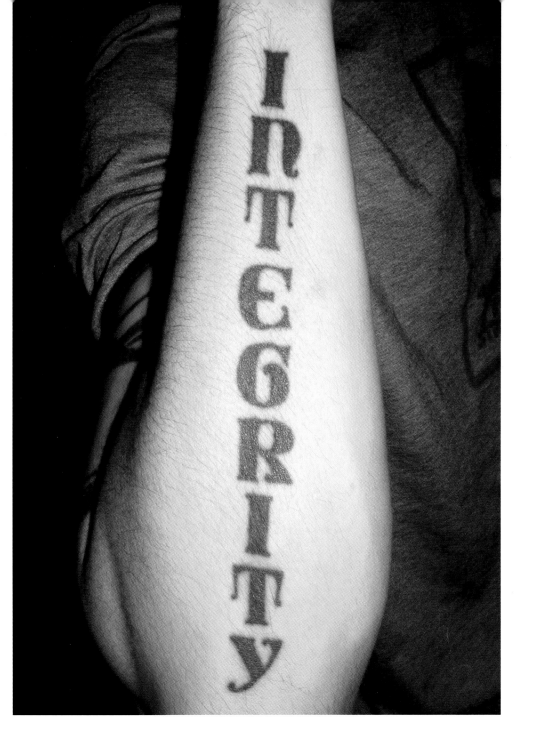

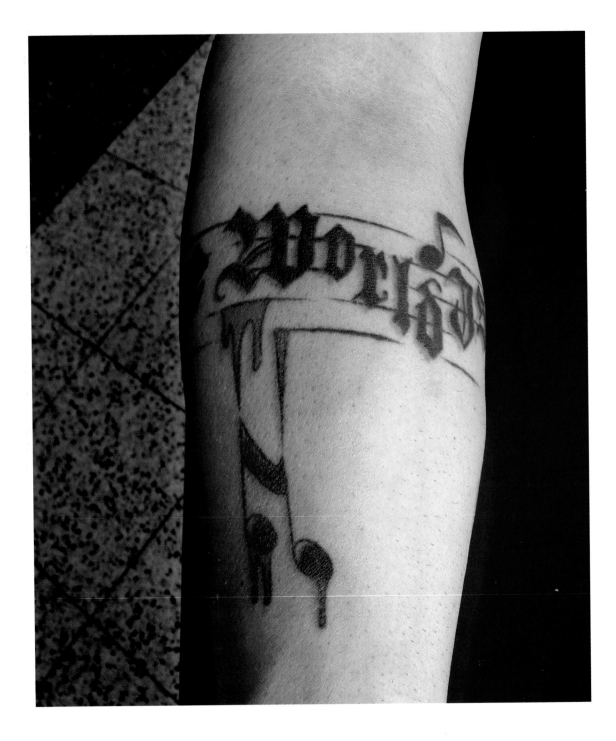

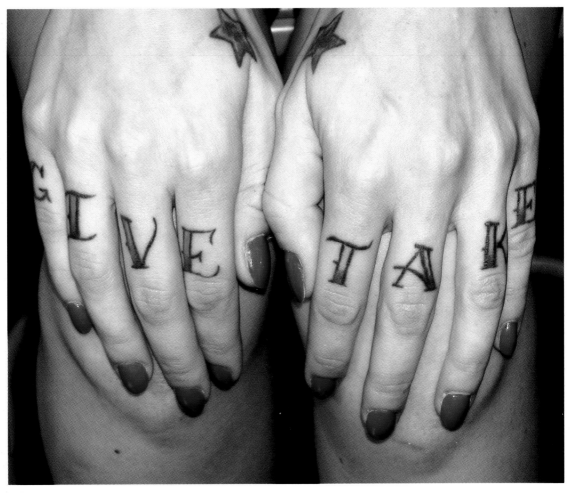

Above: "Life is a balance of give and take."

Left: "It's a *Scarface* thing, 'The World is Mine.' The world is out there to get if you want it . . . you determine what you want to be. The musical imagery is there because I am a radio DJ."

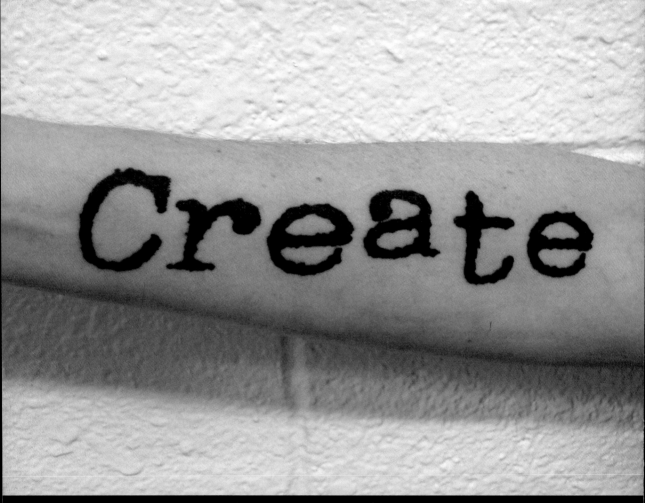

"To me, this tattoo means more than what most people associate with the word 'create.' I believe that our society has been put in a position where we are fortunate enough to have a tremendous amount of free time. I also believe that the majority of people are creative, including those who say, 'I don't have a creative bone in my body!' So, for me this tattoo represents my belief that we all should take advantage of the lifestyle we have, get over our fear of not being creative, and make something. Anything. Once we take this small step who knows where it will lead? I do know that without this small step we will not progress."

SEVEN: CREATIVITY & EXPRESSION

OUR STORIES, OUR ART, OURSELVES — products of the creative imagination abound as tattooed text. We invest these tattoos with our own brand of meaning, whether they are humorous or dead serious (or sometimes both).

The urge to create is a powerful one, celebrated in many tattoos. The endowment of talent is precious, and many choose to pay tribute with an indelible reminder of that gift. For some, the tattoo may also serve as motivation for strength and clarity of purpose, so we may use our creative powers wisely and well.

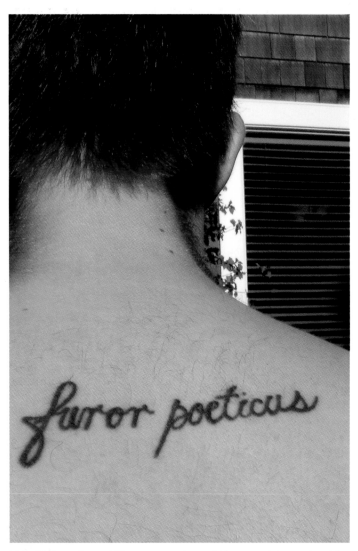
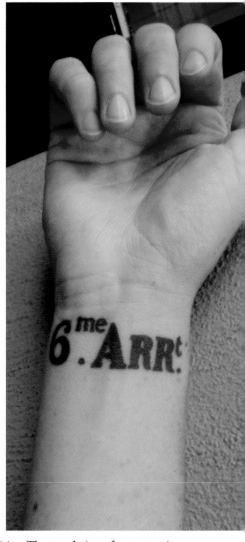

Left: "I always knew if I got a tattoo it would be something to do with writing. The translation of my tattoo is 'the inspired frenzy of the poet.' In high school I worked on a spoken word/poetry fusion and dance collaboration. I'm a recent grad with a degree in English, and I had my Latin professor verify the translation of the phrase."

Right: "A few years ago, on a trip to Paris, I decided that writing would be a career for me and not just a hobby. I took a photo of a Parisian street sign and had the tattoo artist match the look of it exactly. The Sixth Arrondissement is a neighborhood where there was a community of artists who worked and lived and sometimes collaborated: Picasso, Hemingway, Gertrude Stein, T. S. Elliot. I live in a similarly creative community."

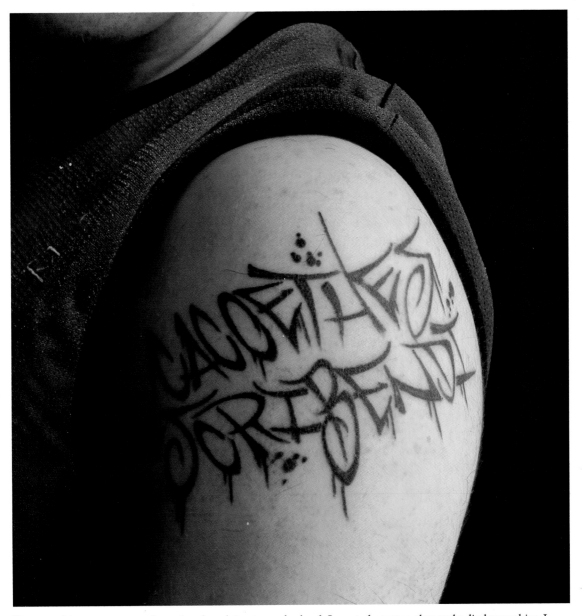

"I am working on my second novel and applying to grad school. I wanted a tattoo that embodied something I was passionate about, something that would never change about me. I know I will always love writing. And it is something original, something that no one else will have. The phrase is from the Greek writer, Juvenal, from his most famous work, *The Satires*; it means 'the insatiable urge to write' or 'the bad habit of writing.' The lettering was customized for the space and designed by the artist to look handwritten, complete with ink splotches."

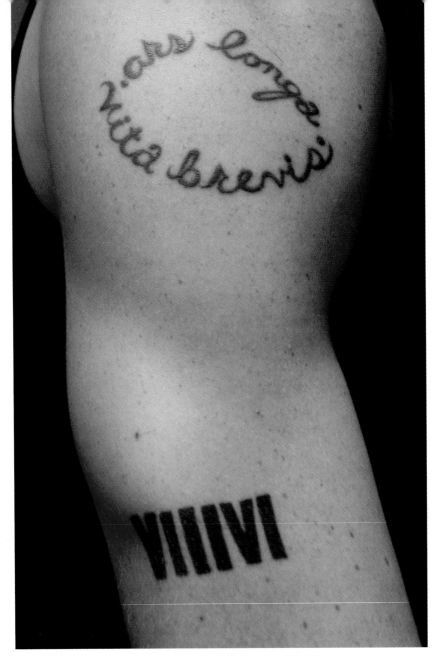

"I got the 'ars longa, vita brevis' tattoo [art is long, life is brief] because it is an incredible statement that really rings true: if you can create something that the world will be moved by, then you will be remembered beyond your lifetime. I like that. The VIIIVI tattoo is for my birth year, 86, or 1986."

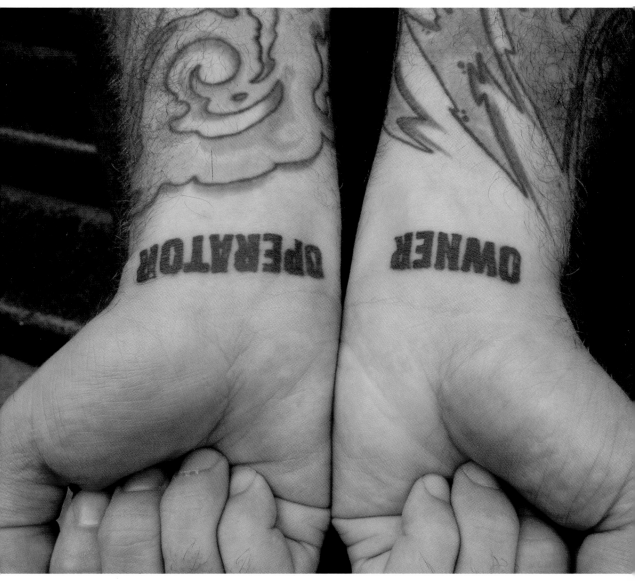

" 'Owner/Operator' is a phrase that usually refers to truck drivers. For me, as a designer, it's about being responsible for my own form-making. Everything I make has a custom aspect to it. Many artists don't make all the components of their art."

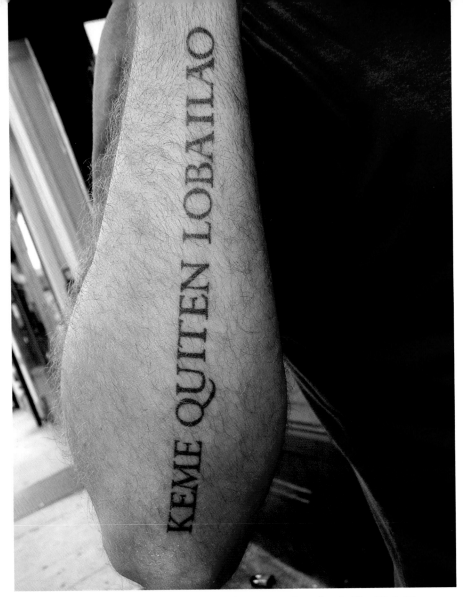

Above: "I am from Barcelona. This is my fourth tattoo, and my first in New York City, where I have been living for over ten years. It means 'this is my life and I can do whatever I want.' It is a statement of who I am and of the freedom in the way I live my life."

Right: "I am a structural engineer by day and an artist by night. I'm fascinated by the simple beauty of old typewriters, and typography in general. When I got my first vintage typewriter, I started making typographic art with it, creating a visual field that had no textural meaning. The unpredictability of the type, due to the age of the typewriter, creates a random gradient."

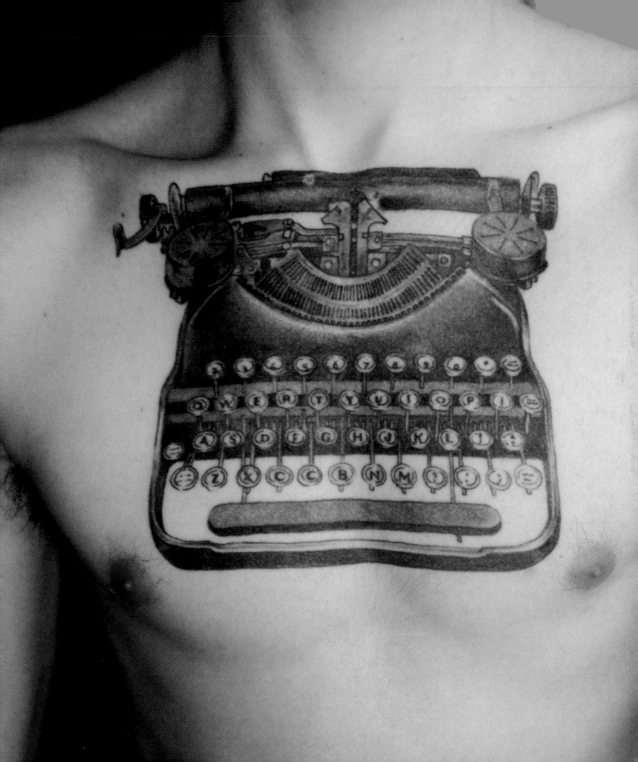

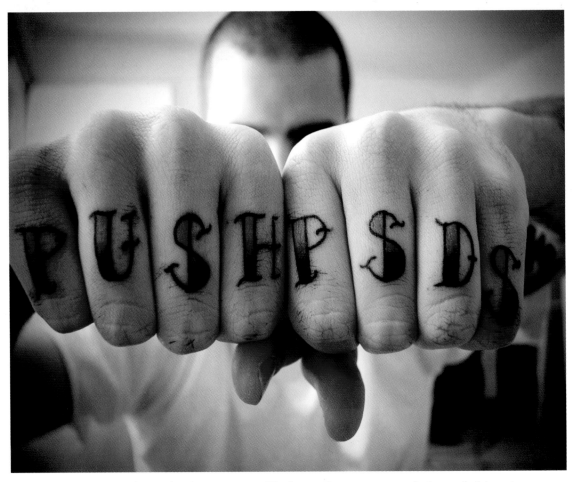

Above: "I got this as a geeky graphic designer tattoo. You know when someone works in an administrative position, they're called 'paper pushers'—I work with PSDs (Photoshop documents)."

Right: "This arm is dedicated to my two favorite artists, Da Vinci and Picasso. I paint the female form, so I changed Da Vinci's Vetruvian man to a woman. And the quote is from Picasso, 'Every child is an artist. The problem is how to remain an artist once he grows up.' I wanted the type to resemble Da Vinci's handwriting and had it tattooed in reverse like his mirror writing to tie the two artists together."

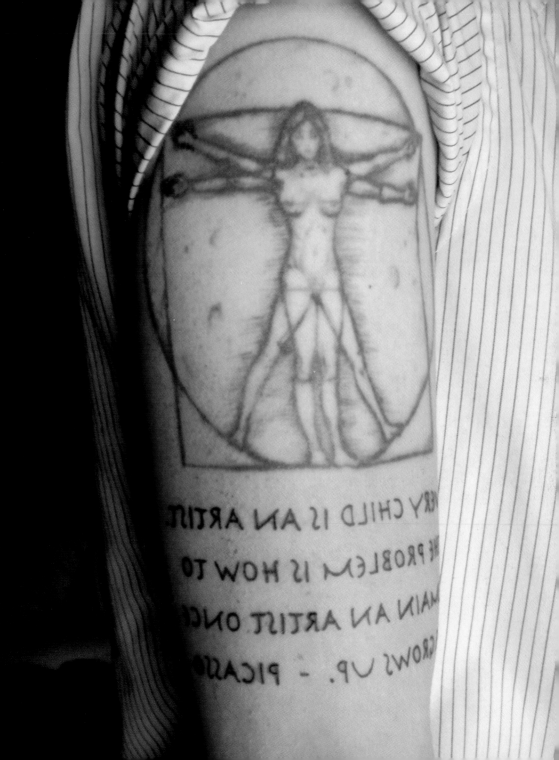

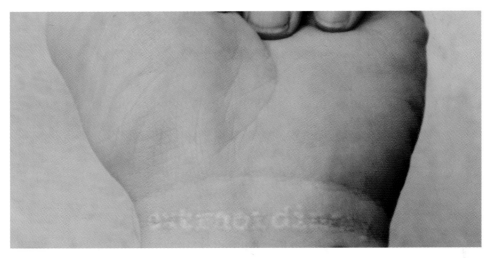

Above: "I am an actor, and I get very nervous when I audition. My white tattoos remind me that I am 'extraordinary' and that I must remember to 'breathe.'"

Left: "This is an excerpt from my own poem, written as part of a spoken word class with Karen Finley at NYU. The type is called Ribbon (coincidentally my favorite band's font—The Deftones)."

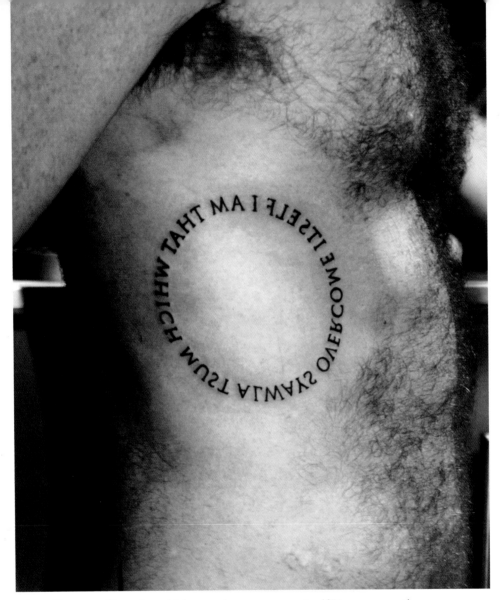

Above: The quote, "I am that which must always overcome itself," in reverse so the wearer may read it in the mirror, is from Nietzsche's *Thus Spoke Zarathustra, On Self-Overcoming.*

Right: "I am a hip-hop artist. I wanted a tattoo that would represent all of my important influences and connections but I did not want clutter. I went to a Web site that allows you to create your own word search and I entered ten words and phrases: *Jskills* (my old stage name), *SoSoon* (my current stage name), *musicisart, artislife, Queens Official* and *Cataclysm* (my former groups), *Hunter* (my college), *hiphop, rhythmandblues,* and *spokenword.*"

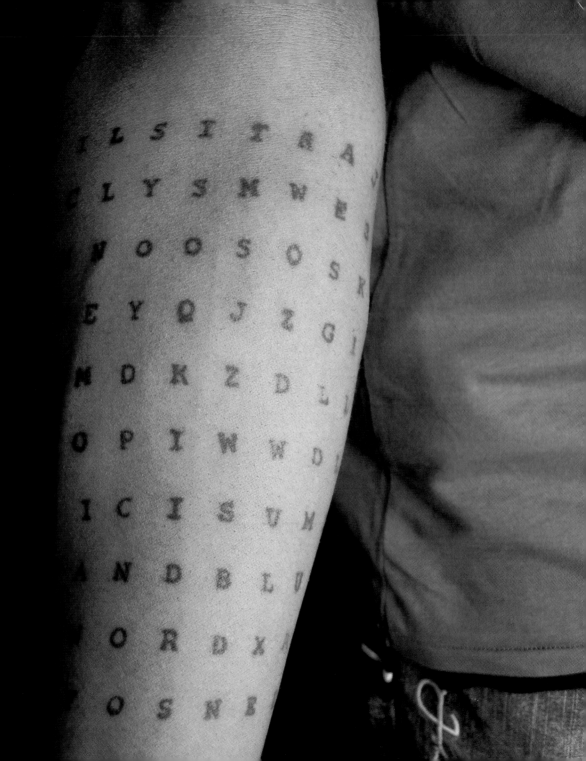

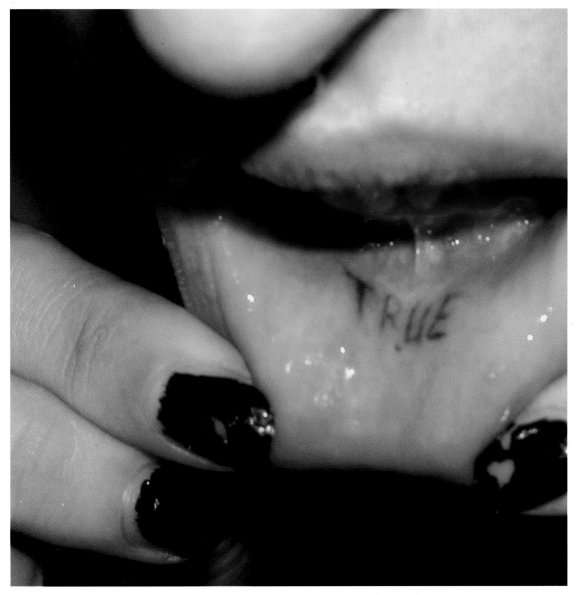

Above: "My friends and I often use the word 'true' when we are agreeing with one another, and it has become a kind of secret code for us. I decided that instead of saying it so much I would have it tattooed inside my lip, then I could just pull my lip down and show it."

Left: "I designed this semi-abstract symbol that reads 'love/fear' because I am trying to find the balance between the two forces. Finding harmony in the middle allows you to find harmony as a human being."

"I work in a place that rents motorcycles, and all day long I teach people how to ride . . . so I am constantly saying 'brake' and 'clutch.' I decided to get each of those words tattooed on my arms so I could just show them instead of repeating it all the time."

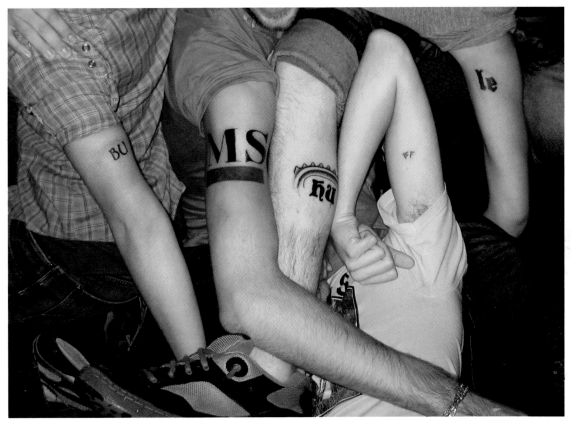

"A friend and I had the idea for a bicyle race we called the Columbus Bumshuffle (in Columbus, Ohio), and three other friends helped us organize it, so after the race the five of us decided to get a commemorative tattoo. We took a nice stroll through the font book and we each chose two of the ten letters in the word 'bumshuffle.'"

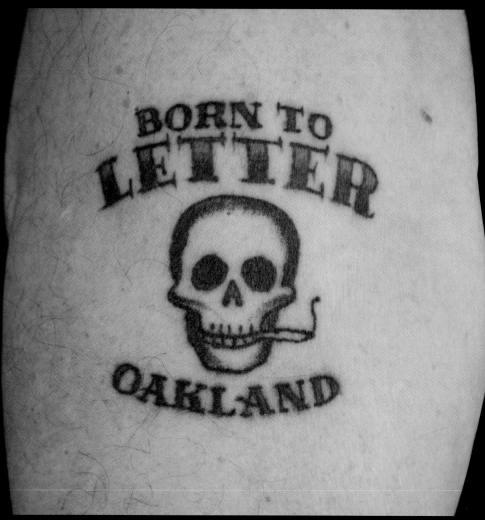

"I am a lettering artist. For years I would joke to my friends that if I ever got a tattoo, it would say 'born to letter.' Finally, someone challenged me to stop talking about it and just get the tattoo. So I did."

EIGHT: TYPOGRAPHY

TYPOPHILES AROUND THE WORLD REJOICE in the ecstasy of letterforms. Not surprisingly, many of those whose chief preoccupation is typography have chosen to commit that passion to skin. Celebrating and obsessing over typography, these tattoos provide a window into the tightly knit world of those whose kinship with typography is absolute: graphic designers, typographers, type designers, and type scholars.

What might seem arcane to the rest of the world is the stuff of magic to these professionals and aficionados. Letters, after all, have transmitted and preserved all that has been learned in the past. What signs and symbols are more worthy of adoration and commemoration?

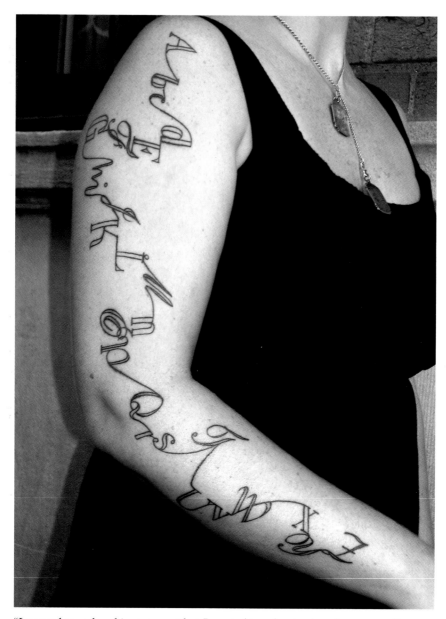

"I wanted to make a big statement but I wanted it to be timeless. I was struggling with an idea until I thought of the alphabet. I wanted it to be fluid and connected. As an artist, I know that in this day and age people are inundated with messages so it is hard for them to really hear anything . . . people look at this tattoo and they really want to figure it out. It helps break the ice."

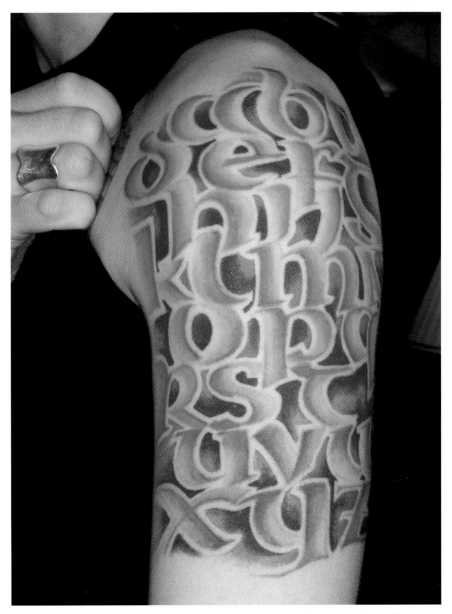

"I still send mail the old-fashioned way and had long wanted a tattoo of something written. I think handwritten script is fast becoming a lost art, so the choice of calligraphy was easy. This alphabet in half uncial says everything I need to."

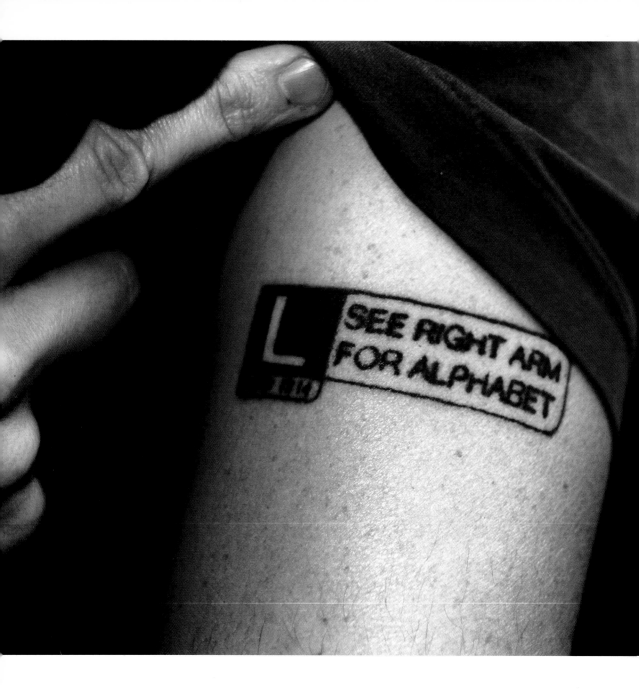

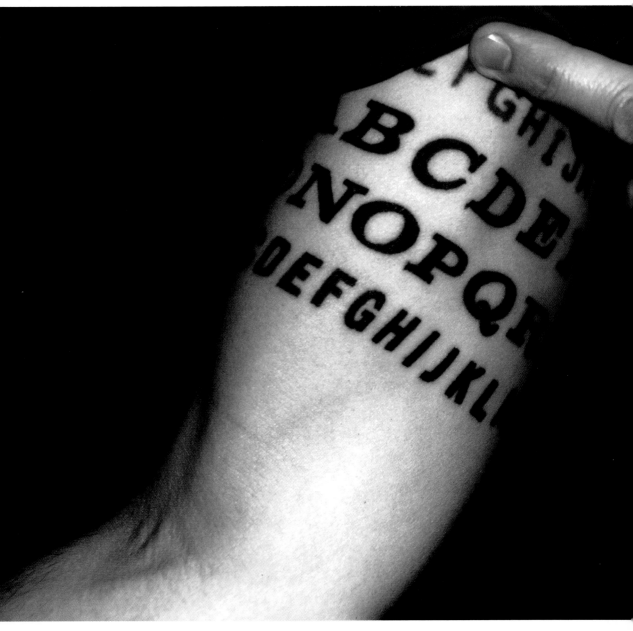

"Before I became a designer, I had the idea of the alphabet as a timeless message. My typeface choices were Volta Bold and Trade Gothic Bold Condensed. When I started working professionally and then launched my own design business, a client suggested using 'Alphabet Arm' as my name. It has come to define me."

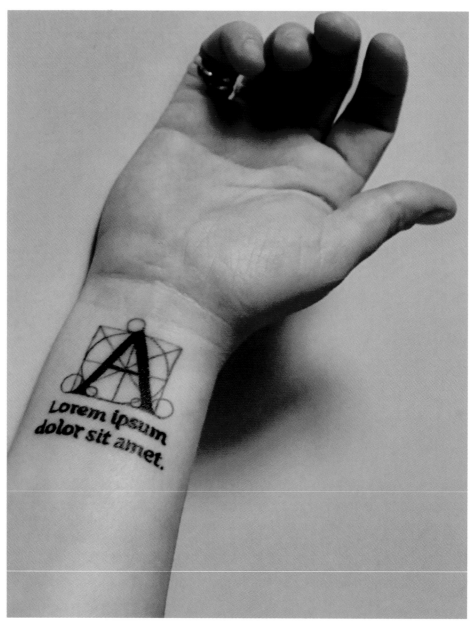

"I am an Aussie living in Ireland, a photographer, designer, and 'type nut.' When people ask me what the type means, I take pleasure in saying, 'Actually, nothing,' but of course it signifies something to me and others who recognize its meaning. It is set in Fertigo, 22 point. The drawing above is my initial, drawn by Leonardo da Vinci, based on the golden section rectangle."

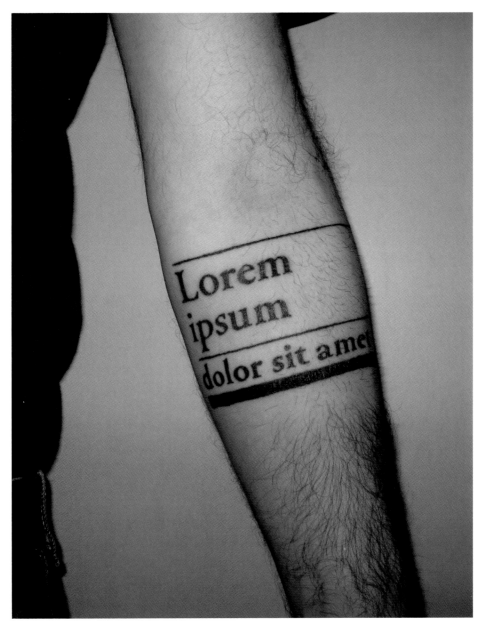

"I am a graphic designer from France and a font addict. I got this tattoo while visiting New York City, and the morning before I got the tattoo I happened to find *Body Type* in the MoMA Design Store in Soho. I didn't want to sport any message, just plain letters; the classic 'lorem ipsum' placeholder text, in classic Garamond, for the sheer pleasure of graphic delight."

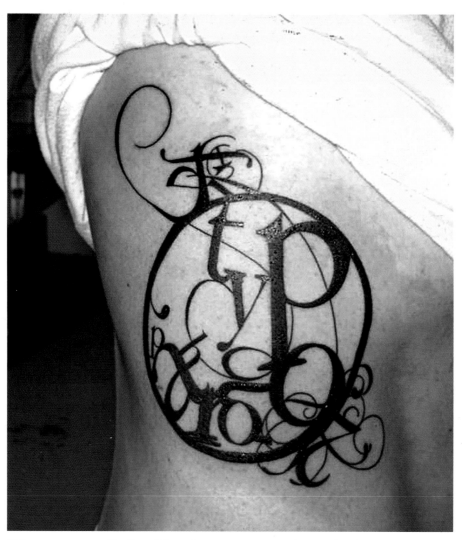

"My tattoo is inspired by David Carson's quote, 'Don't mistake legibility for communication,' and also my true love and passion for the art of typography. It consists of two typefaces with 'typography' in the middle and other letter and number forms creating the overall design. Type breaks the barrier of the circle, as I believe it should."

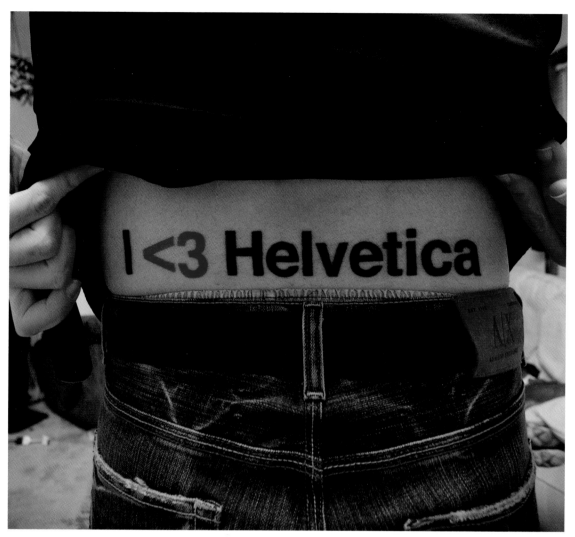

"My 'I <3 Helvetica' tattoo is a departure from the conventional body art invested with a deep, personal meaning. True, I do love this typeface, but I got it more as a joke in an attempt to expose the ludicrous argument either for or against the quality of Helvetica. Not to mention I love the novelty of this piece. I mean, after all, it is a tramp stamp."

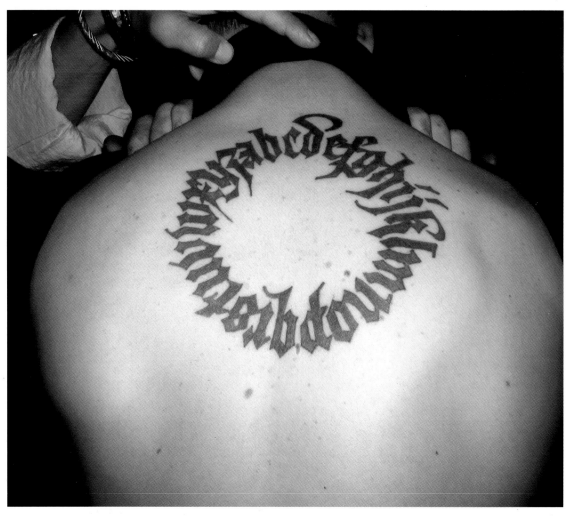

"I have always been interested in calligraphy and letterforms. I carved my own pens from bamboo and drew this alphabet loosely based on an 1850s German blackletter. I carried the design around in my pocket for years, thinking one day I'd get it tattooed. It is my only tattoo, an homage to my brother, who was a tattoo artist and who passed away."

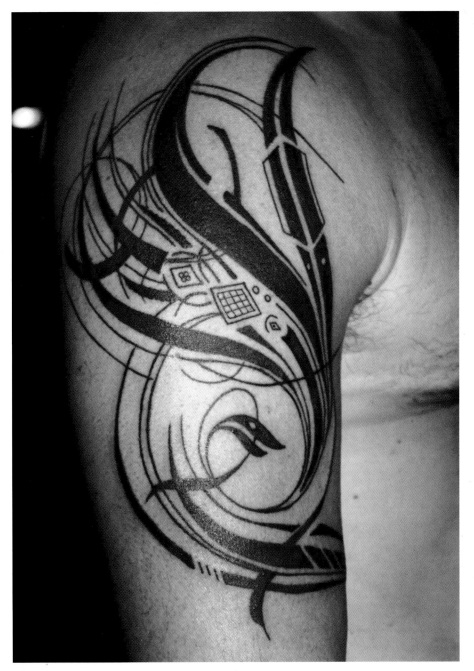

This is a heavily embellished initial *S*, a contemporary riff on historically ornate initial capitals.

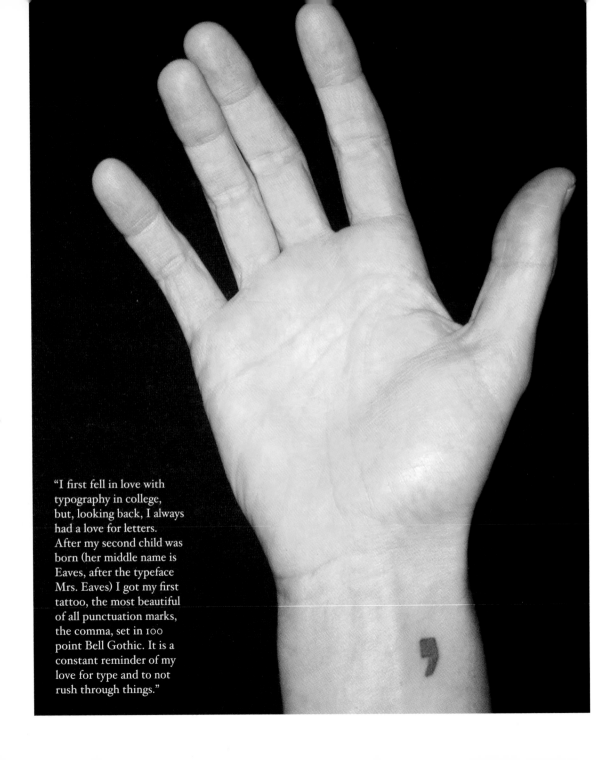

"I first fell in love with typography in college, but, looking back, I always had a love for letters. After my second child was born (her middle name is Eaves, after the typeface Mrs. Eaves) I got my first tattoo, the most beautiful of all punctuation marks, the comma, set in 100 point Bell Gothic. It is a constant reminder of my love for type and to not rush through things."

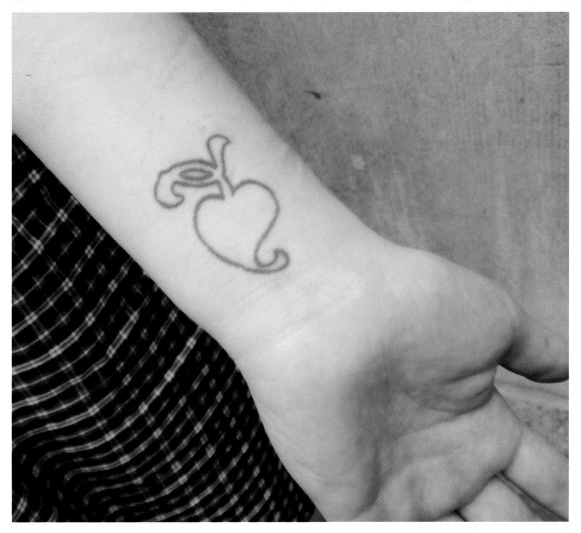

"This is a Goudy type ornament, which I modified a bit to make it less ornamental, and also to create it as an outline. I got this tattoo when I realized that graphic design was what I wanted to do forever. I got it on the inside of my wrist, which is intimate, but not sexual."

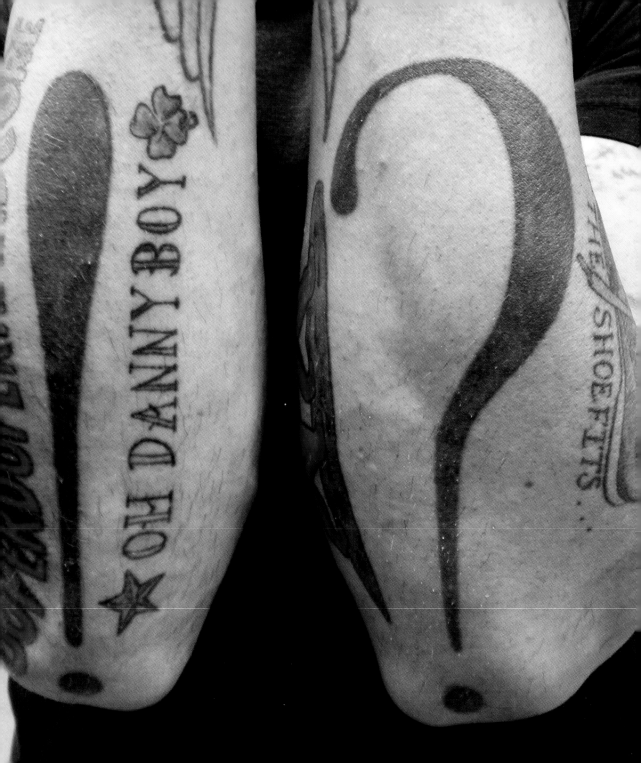

Above: "The *B* is from a handpainted font from Barry McGee. The letter is for my cat, Banyan, and also because I am a big fan of the artist."

Left: "I came to a turn in the road, and I had a really big question . . . and then I got a really big answer."

"I found this in the 1882 type catalog of George Bruce's Son & Co., which has 2600 typographic ornaments and designs. This design is used as a dingbat or swash or line spacer; an ornamental way to break up text. I was thinking of getting an ampersand but the swash is still typographic while speaking to the design side of what I do. It fits perfectly the way it mirrors the arc of my calf. The original art was one inch long."

"My question mark is easy for me to see. It is a reminder not to take our humanity and the ability to question for granted. The typeface is Century Gothic. If you are not familiar with that typeface, you might not know what it is . . . I like the uncertainty."

"I wanted a design-related tattoo because I'm a designer. I loved seeking out glyphs; I always thought the dagger was the most interesting. It is edgy, unique, and mysterious. I searched through many typefaces and chose Bodoni because it is elegant and classic. I like the way it runs along the bone of my wrist. I became interested in getting a glyph when I was at TypeCon in Boston in 2005. I was sitting behind someone with an umlaut tattoo just as I was looking through *Body Type,* and then I saw his tattoo in the book!"

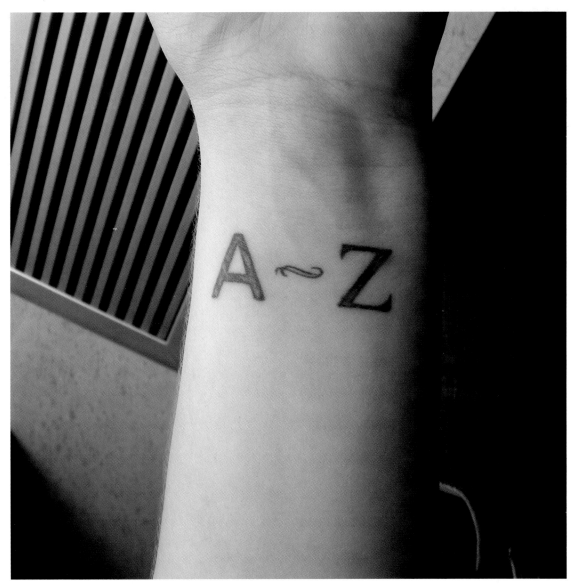

"I was in London for a graduate course in design theory and practice at the University of the Arts. I moved to New York for a job and a guy, and two months later, everything fell apart. I wanted to get a tattoo but couldn't decide what. I came up with the idea of *A–Z* to represent 'from one extreme to the other.' The *A* is Univers 55, the '⌐' is from Woodtype ornaments, and the *Z* is Times New Roman. It is a simple tattoo but it has a lot of meaning behind it . . . it is a reminder that when things are really bad, they can turn around."

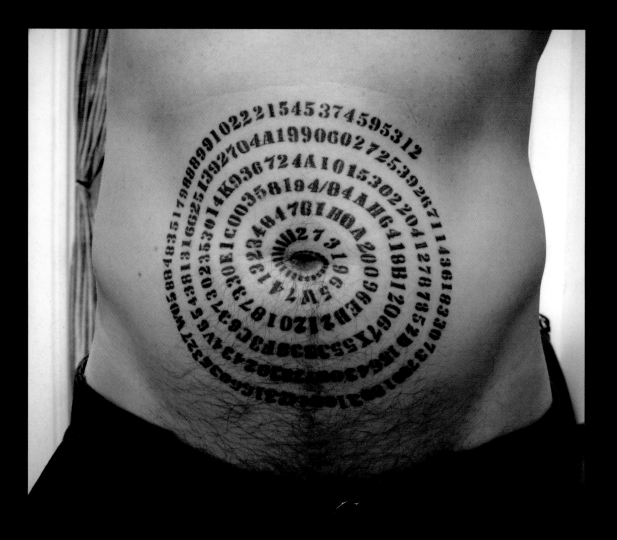

"My tattoo is an ongoing artwork called 'Define Me' that comprises a series of identification numbers and letters, starting with my birth date at my navel, and proceeding in sequence through my Irish social security number, my Irish passport number, Irish driver's license, U.S. alien registration number, U.S. social security number, U.S. naturalization number, U.S. passport number, U.S. driver's license, and more. I plan to add characters as they are given to me throughout my life."

NINE: NUMEROLOGY

NUMBERS HAVE A SPECIAL POWER. Various societies and cultural groups have attributed unique qualities to numerals. Governments often attempt to define us through numbers. Numbers may be mystical or meaningful, and, unlike letters, numbers can permutate through mathematical means. But whether added, subdivided, or multiplied, numerical forms are a special subset of typographic forms.

Descended from a different set of shapes than letterforms, which come to us mostly from the Greeks, Romans, and Phoenicians, numbers have distinctly separate shapes. When they combine, they create quantities rather than words. Some of the diverse purposes and implications of numbers are shown here by those who have chosen to express themselves numerologically.

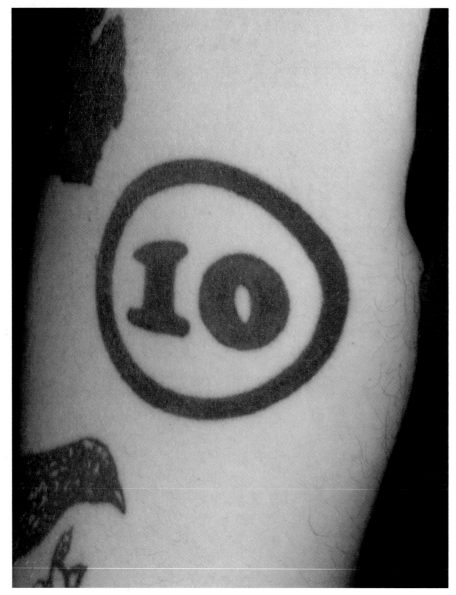

Above: "This circled number ten is in the typeface Cooper Black, and it has many private meanings for me."

Right: "The words of the numbers *893* correspond to the Japanese character for Yakuza. I am a film and photography major, and a fan of the Japanese gangster movie genre (similar to the American film noir genre)."

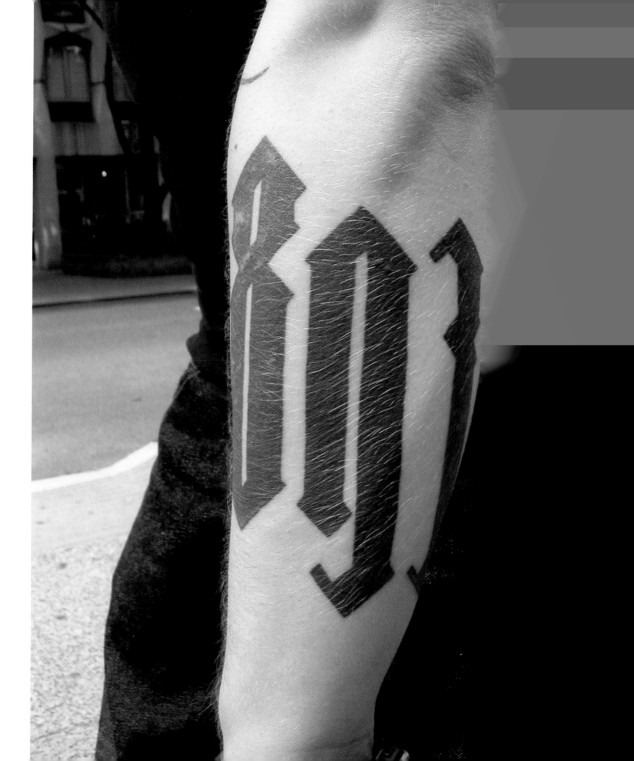

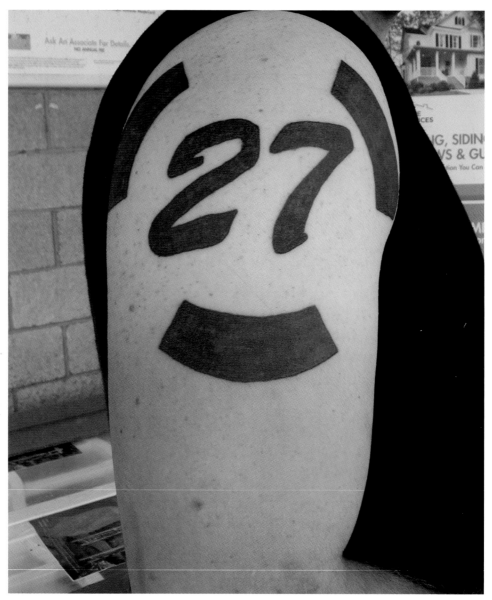

"This is the name of a team of eight superheroes that I have been drawing since I was nine years old, they are called 'Chapter 27.' I had the number tattooed inside the symbol for a fallout shelter, showing that even in the worst of conditions, you'll always be safe (within yourself)."

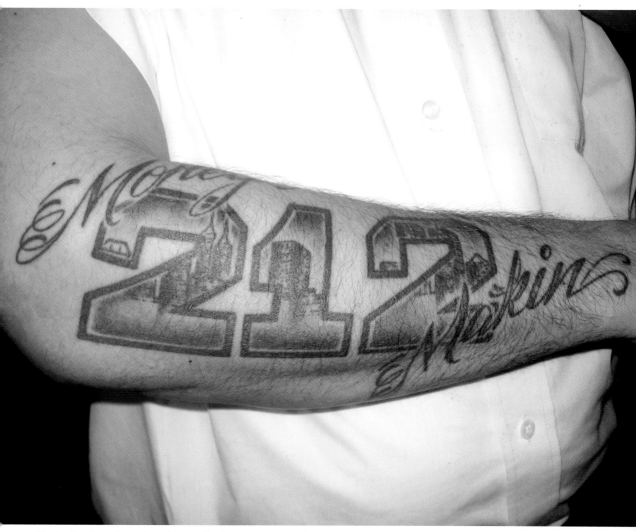

Dating back to the early 1980s, each of New York City's boroughs became known by a "street" nickname such as "Money Makin' Manhattan." Here, instead of spelling out Manhattan, the cityscape is depicted inside the outlined numerals of its highly coveted 212 area code. The Beastie Boys used this phrase in their song, "Super Disco Breakin'."

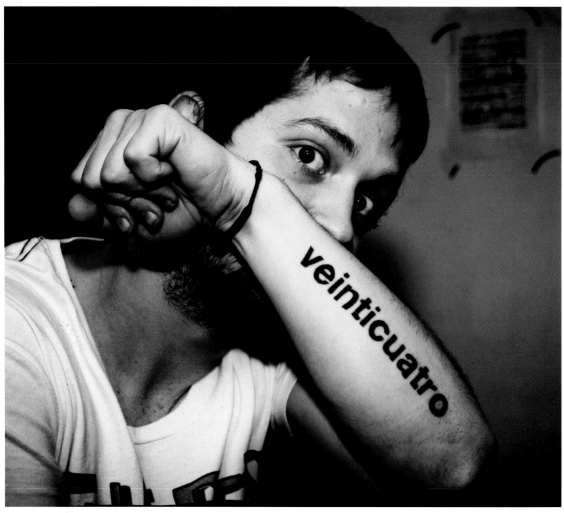

"I am a creative director in Paraguay. I got a Helvetica type tattoo that means twenty-four in Spanish, because when I was born, on June twenty-fourth, a friend of my mother's gave her a letter which she had written. She said that special characteristics surrounding the number twenty-four described my personality and my aspirations in life. My mother showed me the letter on my twenty-fourth birthday, and I found that it expressed everything that I wanted in life. A few months after my birthday, my mother passed away. Why Helvetica? Because it is timeless and I want to keep these insights for the rest of my life."

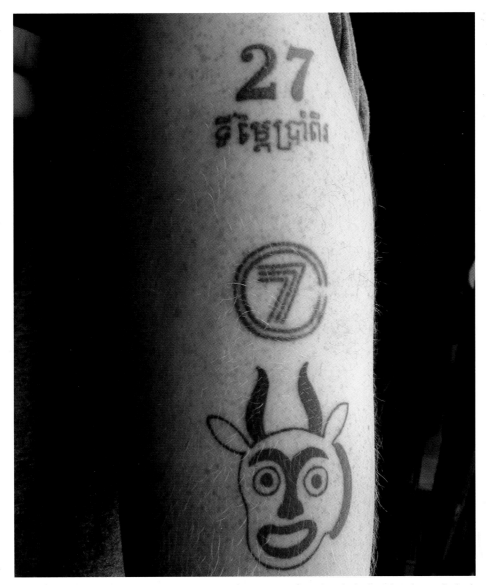

"Twenty-seven is my lucky number. And as for the seven, a friend and I had a joke where, if asked a question, the answer was always seven. What time do we leave, what's your shoe size, how much does it cost? Seven. I was standing in front of a tattoo place looking in the window. He asked, 'You're not thinking of getting a tattoo, are you?' I said, 'I'm thinking about getting a seven.' He reached into his pocket, pulled out a $100 bill, and said, 'Get a receipt.'"

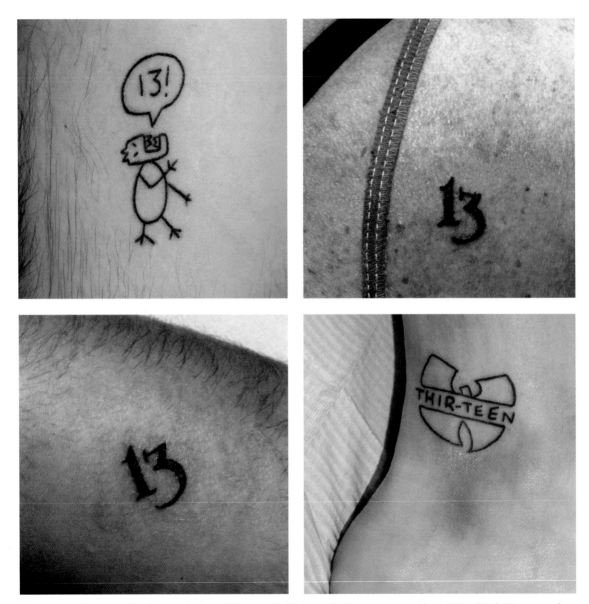

Every year, whenever the thirteenth day of the month falls on a Friday, a tattoo parlor in New York City gives free tattoos of the number thirteen.

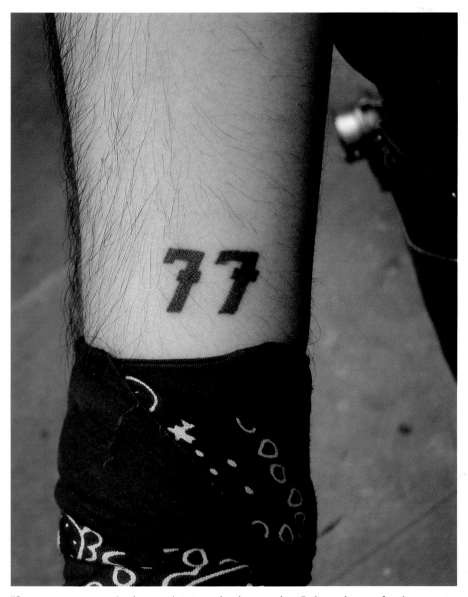

"Seventy-seven is my 'jock tattoo'; it is my hockey number. I chose the typeface because it looked European to me."

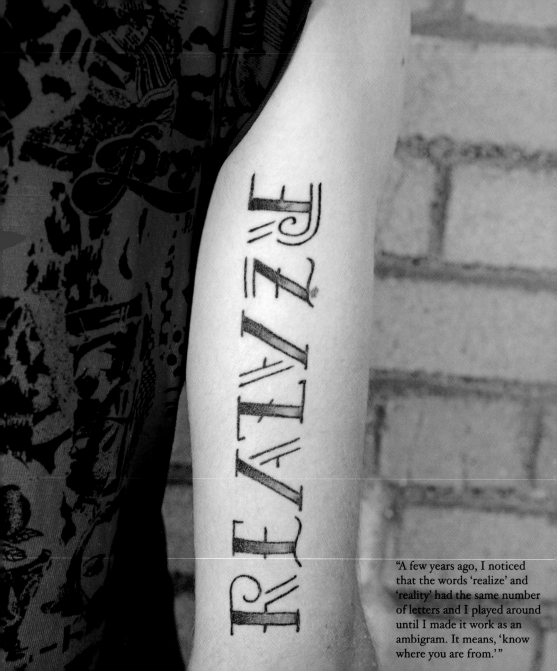

"A few years ago, I noticed that the words 'realize' and 'reality' had the same number of letters and I played around until I made it work as an ambigram. It means, 'know where you are from.'"

TEN:
AMBIGRAMS

THE MYSTERIOUS INTERSTICES of letterforms and the resulting ambiguities of legibility have been explored by many talented designers. Ambigrams are words or phrases that read the same whether upside down or right side up. Asymmetrical ambigrams create words (or names) in both directions, or as a mirror image, and the messages differ depending on the viewer's orientation.

It takes a special eye to discover and tease out the ambigrammatical possibilities inherent in certain letter combinations. One artist who specializes in designing ambigrams for tattoos is Mark Palmer of Wow Tattoos in Los Angeles. Robert Langdon is well known for his ambigrams, and other artists are beginning to discover the joys and challenges of the form.

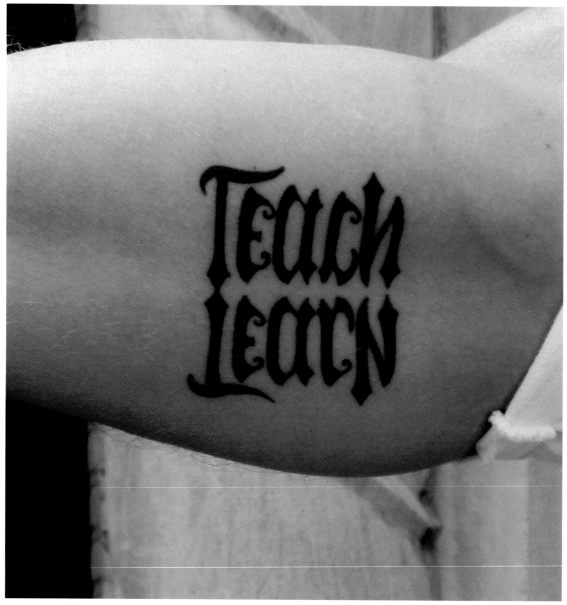

Above: (Teach/Learn, mirror ambigram) "I taught middle school in New York City for eleven years, now I write books for kids."

Right: (New Orleans) "I volunteer in New Orleans, helping to rebuild; I have been there eight times so far. I liked the goth feel of the design, and the musicality of the letters. It is very New Orleans."

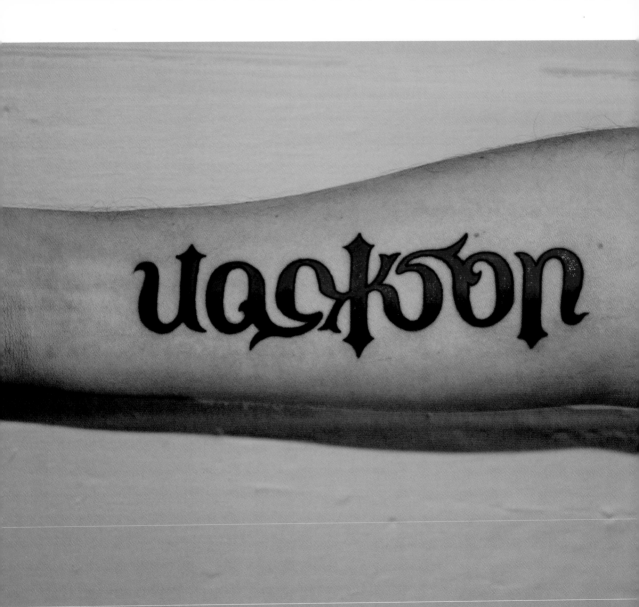

Above: Jackson. *Right:* Faith.

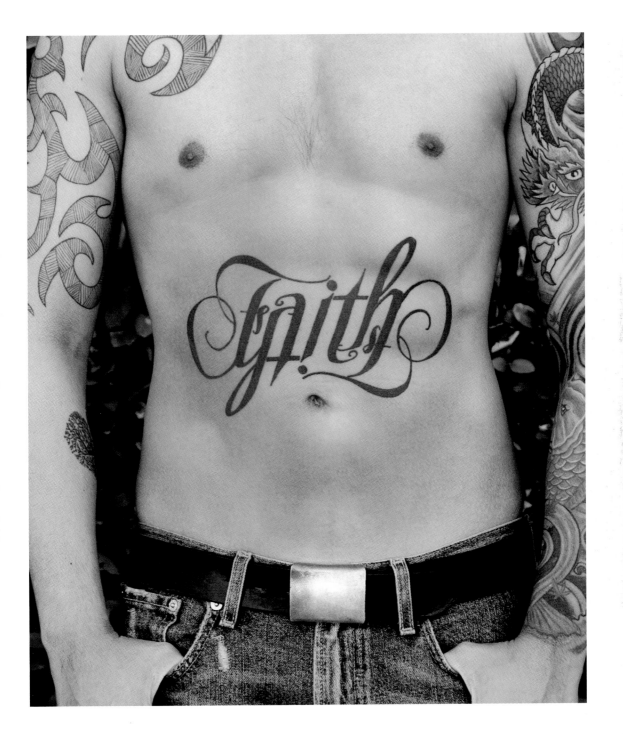

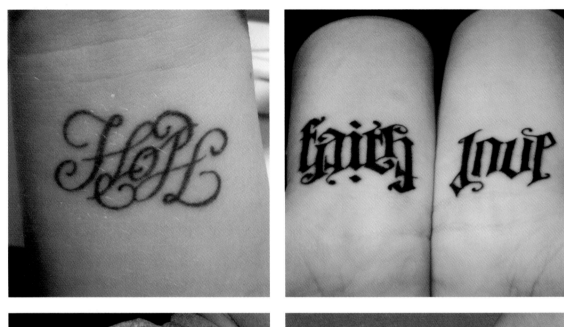

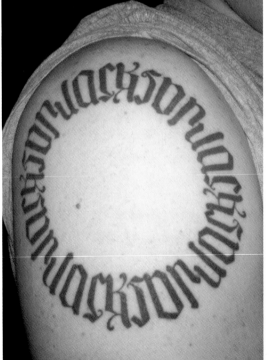
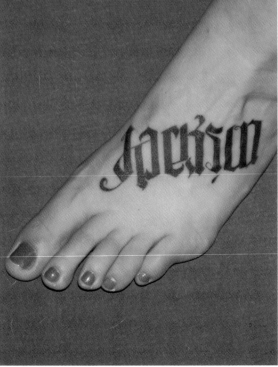

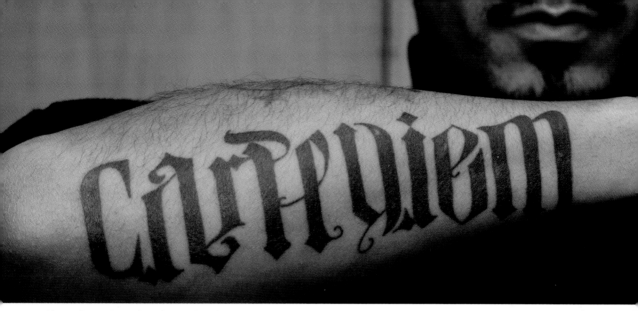

Above: Carpe Diem/Work Hard. *Below:* Strength, Genetics.
Opposite page, clockwise from top left: Hope, Faith/Love, Jackson, Jackson/Miracle.

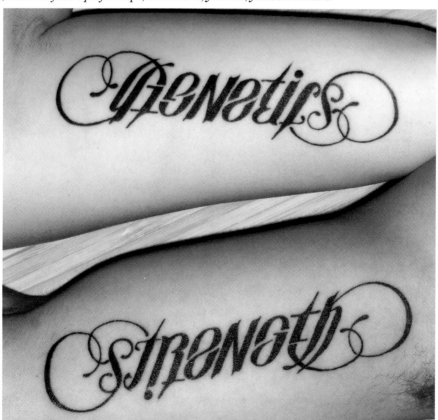

LOST AND FOUND

In this very spot in *Body Type: Intimate Messages Etched in Flesh*, I wrote a paragraph called "The Ones That Got Away . . . ," about the tattoos that, for one reason or another, never made it into the book. One of these was "the guy in the New York City subway system with the giant exclamation point tattoo." (When I spotted him in the Times Square subway station, he was rushing off somewhere and could not wait to hear me explain why I wanted to photograph his tattoo right then and there, nor to tell me how to contact him.)

The funny thing about books is that they take on a life of their own, penetrating into unexpected places and generating unforeseen connections. After *Body Type* was published, someone who read this page in my last book e-mailed me to say, "I know that guy; he's a friend of a friend." I e-mailed back to say I'd like to reach the "exclamation point guy." The reader who contacted me forwarded my e-mail to his friend, who forwarded it to her friend (the aforementioned "exclamation point guy"), but my message apparently got stranded in his spam folder and I never heard from him.

I had plenty of other leads to follow and subjects to document, so I did not pursue it further. But more than a year later, just as I was putting the finishing touches on this book, I received an e-mail from "exclamation point guy," saying that he had seen my book and loved it, and had found my e-mail while going through old messages in his spam folder, and could we get together?

Now you can finally see his photograph, on page 164.

ACKNOWLEDGMENTS

This volume of *Body Type 2: More Typographic Tattoos*, was in some ways easier to assemble than its predecessor, and in some ways it was more difficult. The first volume provided a helpful template of sorts. While many people contacted me because they had encountered *Body Type*, its popularity gave me a lot to live up to in this volume. I have inevitably become more discriminating: more than a third of the tattoos I photographed and the accompanying interviews did not make it into this book because I needed to edit the book to a specific length. However, like *Body Type: Intimate Messages Etched in Flesh*, serendipity played a divine role in many of the typographic tattoos that came my way for this book: tattoos spotted while shopping, strolling, visiting a museum, going to an opening or a show. But I could not spot them all by myself. Many thoughtful friends sent likely subjects in my direction. While I cannot mention everyone by name, in particular I want to thank Nathalie Kirsheh, Daniel Gardiner Morris, Paul Craven, Brian Kelly, and Susan Hunt Yule.

I thank my editor, Tamar Brazis, for her sage advice, patience, and enthusiasm for *Body Type 2*, and my publisher, Michael Jacobs, for his willingness to have another go at typographic tattoos.

My good friend, sometime colleague, and typographic "soul-mate" (as I like to describe him), Donald Partyka, has once again provided sensible and gentle guidance in helping to shape this book. My confidence in his ever-reliable aesthetic judgment is supreme. Nancy Rouemy Harris was helpful in suggesting creative typographic direction. Some very talented photographers generously shared their work with me; I thank Reyes Melendez, Damian Sandone, and Gene Pittman for their important contributions to *Body Type 2*.

I owe a special debt of gratitude to Mike Essl, professor at our mutual alma mater, The Cooper Union for the Advancement of Science and Art, who had the notion to curate a solo show of my photographs from *Body Type*. The opening reception and book signing at Cooper's Lubalin Center, mecca of typographic scholarship, was one of the greatest thrills of my professional life, along with my invitation to speak at the Type Directors Club (thanks to Executive Director Carol Wahler) and at the Art Directors Invitational Master Class (thanks to the always amazing and talented Russell Brown from Adobe). A second photography show followed, when the Newhouse Galleries' museum director Frank Verpoorten requested my work for an exhibition at the Snug Harbor Cultural Center, a handsome and historic venue on the New York waterfront. I thank him for doing a beautiful job of curating my work.

I thank Stephanie Tamez, tattoo artist extraordinaire, who has designed many of the most striking typographic tattoos in this book, as well as in the first *Body Type*. Her skill and passion for typographic form is unparalleled, though the work of many fine artists is represented in these pages.

This book would not exist but for those pictured in its pages. I thank them for their willingness to share the intimacy of their images and their feelings.

Forever and always, my deepest thanks go to my husband Steven Beispel (great dancer, creative thinker, and gifted cook!) whose steadfast support, humor, kindness, and love allow me to pursue my work and my dreams.

CREDITS

p 1: ARTIST *Søren Shiøtt*
PHOTOGRAPHER *Anders Skovgaard*

p 2: PHOTOGRAPHER *Damian Sandone*
ARTIST *David Sena*

p 4: PHOTOGRAPHER *Tim Mantoani*
ARTIST *Bejah*

p 8-9: PHOTOGRAPHER *Steven Beispel*
p 9 (center): PHOTOGRAPHER *Louise Fili*

p 10 (left): PHOTOGRAPHER *Steven Beispel*
(right): PHOTOGRAPHER *Chad W. Beckerman*

p 12: PHOTOGRAPHER *Gene Pittman*
ARTIST *Charlie Forbes*

p 14 (top left): ARTIST *Claire*
(top right): ARTIST *Scott Campbell*
(bottom): ARTIST *Michelle Tarantelli*

p 15: ARTIST *Mondo*

p 16: ARTIST *Josh Moody*

p 17: ARTIST *Claire*

p 18: PHOTOGRAPHER *Katie Albritton*

p 20: ARTIST *Damion Ross*

p 22: PHOTOGRAPHER *David B. Moore*
ARTIST *Joshua "Bedo" Escobedo*

p 23: DESIGNER *Christian Acker;* ARTIST *Dre*

p 25: ARTIST *Tattoo Seen*

p 28-29: ARTIST *Stephanie Tamez*

p 30 (top): ARTIST *Marco Serio; (bottom):*
Yoni Zilber; PHOTOGRAPHER *Bob Sacha*

p 31: ARTIST *Patrick Conlon*

p 34: PHOTOGRAPHER *Dan Alexandru*
ARTIST *Dave Wallin*

p 37: ARTIST *Troy Denning*

p 39: PHOTOGRAPHER *Reyes Melendez*
ARTIST *Jay Boogie*

p 41: PHOTOGRAPHER *and* ARTIST
Virginia Elwood

p 42 (bottom): ARTIST *Raffaele Oliva*

p 43 (top right): DESIGNER *Dylan Menges*
ARTIST *F14HellKat*

p 45: ARTIST *Eric Merrill*

p 52: PHOTOGRAPHER *Jeremy Lacroix*
ARTIST *Ellie Geyer*

p 53: PHOTOGRAPHER *Gene Pittman*
ARTIST *Billy Bacca*

p 54: PHOTOGRAPHER *James Pomeroy*
ARTIST *Edwin Marin*

p 56: PHOTOGRAPHER *and* ARTIST
Stephanie Tamez

p 57: ARTIST *Bailey Hunter Robinson*

p 59: ARTIST *Caleb Barnard*

p 62: PHOTOGRAPHER *Rubistyle*
ARTIST *John Deegan*

p 63: PHOTOGRAPHER *Elizabeth Vegvary*

p 66: PHOTOGRAPHER *Michael Stinson*
ARTIST *Sameerah*

p 67: PHOTOGRAPHER *Cherilyn Colbert*
ARTIST *Monica Moses*

p 68: ARTIST *Stephanie Tamez*

p 69: ARTIST *Søren Shiøtt;*
PHOTOGRAPHER *Anders Skovgaard*

p 70-71: ARTIST *Stephanie Tamez*

p 74: PHOTOGRAPHER *Cam Blackley*
ARTIST *Stephanie Tamez*

p 75: ARTIST *Needles*

p 77: DESIGNER *John Van Hammersveld*
ARTIST *Lucky Diamond Rich*

p 80: DESIGNER *and* PHOTOGRAPHER
Bobby Jordan; ARTIST *James Marlowe*

p 81: ARTIST *Lesley Chan*

p 83: ARTIST *Stephanie Tamez*

p 84: ARTIST *Justin Lipuma*

p 85: ARTIST *Craig Cooley*

p 87: ARTIST *Albert Sgambati*

p 89: ARTIST *JK5*

p 90: PHOTOGRAPHER *Damian Sandone*
ARTIST *David Sena*

p 92: ARTIST *Samantha Bliss*

p 93: ARTIST *Anthony Morelli*

p 94: ARTIST *Stephanie Tamez*

p 98: PHOTOGRAPHER *Ben Scott*

p 98: ARTIST *and* PHOTOGRAPHER
Michelle Myles

p 101: DESIGNER *and* PHOTOGRAPHER
screaMachine; ARTIST *Nala Smith*

p 107: ARTIST *Stephanie Tamez*

p 112: ARTIST *and* PHOTOGRAPHER
Stephanie Tamez

p 113: PHOTOGRAPHER *Reyes Melendez*
ARTIST *Darren Rosa*

p 116: PHOTOGRAPHER *Gene Pittman*
ARTIST *Billy Bacca*

p 118: ARTIST *JK5*

p 119: ARTIST *Hoffa*

p 120: ARTIST *Stephanie Tamez*

p 123: ARTIST *Carlos Castro*

p 125: PHOTOGRAPHER *Tim Montoani*
ARTIST *Bejah*

p 128: ARTIST *Mike Bruce*

p 130: ARTIST *Carlos Castro*

p 132: PHOTOGRAPHER *Alex Johnson*
ARTIST *Jeff Houston*

p 135: ARTIST *Craig Messina*

p 137: DESIGNER *Tal Lening*
ARTIST *Troy Denning*

p 138: ARTIST *Stephanie Tamez*

p 139: ARTIST *Andreana*

p 140: ARTIST *Chris Toler*

p 141: ARTIST *Brad Stevens*

p 144: PHOTOGRAPHER *and* ARTIST
Stephanie Tamez

p 145: ARTIST *Shantar Gibson*

p 150: PHOTOGRAPHER *Ed Rachles*

p 152: ARTIST *Stephanie Tamez*

p 152: ARTIST *Liz Gruesome*

p 154-155: PHOTOGRAPHER *Janet King*

p 156: PHOTOGRAPHER *Amy French*

p 157: ARTIST *Stephanie Tamez*

p 159: PHOTOGRAPHER *Glenn Sorrentino*
ARTIST *Graham Fisher*

p 160: DESIGNER *Perry Hazlett England*

p 161: DESIGNER *Tauba Auerbach;* ARTIST
and PHOTOGRAPHER *Stephanie Tamez*

p 162: PHOTOGRAPHER *Nikki Villagomez*

p 164: ARTIST *Scott Harrison*

p 165-166: ARTIST *Stephanie Tamez*

p 168: ARTIST *Stephanie Tamez*

p 170: DESIGNER *and* PHOTOGRAPHER
screaMachine; ARTIST *Nala Smith*

p 178: PHOTOGRAPHER *and* ARTIST
Michelle Myles

p 180: DESIGNER *Joshua Wittner*
PHOTOGRAPHER *Gene Pittman*

p 182-187: DESIGNER *Mark Palmer*

*Special thanks to Mark Palmer: wowtattoos.com
and Stephanie Tamez: stephanietamez.com*

Visit *bodytypebook.com* for more body type.

This book is set entirely in Hoefler Text,
an eminently legible and handsome oldstyle
typeface designed by Jonathan Hoefler.

Its pages were laid out and its typography
was styled using Adobe InDesign CS4
on a G5 iMac.

Body Type 2 was printed and bound at
CC Joint Printing Company Ltd. in
Shanghai. The interior pages are printed
on Gold East matte art paper; its case
and jacket are printed on Gold East
glossy art paper.

INA SALTZ is an art director, designer, design critic, photographer, and professor whose areas of expertise are typography and editorial design. Her first career spanned more than twenty years as a design director for large-circulation national and international magazines, including *Time* magazine's international editions.

In her second act, Ina is a professor in the Electronic Design and Multimedia Program at The City College of New York, and is a member of the design faculty of the Stanford Professional Publishing Course. She also teaches virtually for Stanford via webcast.

Ina frequently lectures on topics related to magazine design and typography, and consults at companies located as far afield as Moscow and Amsterdam. She has authored fifty articles for design magazines, including *STEP Inside Design*, *How*, *Inked,* and *Graphis*.

Ina received a BFA from The Cooper Union for the Advancement of Science and Art in New York City, where she lives with her husband. She has no pets or tattoos, although she does have favorite typefaces (Bickham Script, Requiem, and Franklin Gothic No. 2) and favorite characters (&, Q, Z, R).

Body Type 2: More Typographic Tattoos is her third book.